Digital
Photography

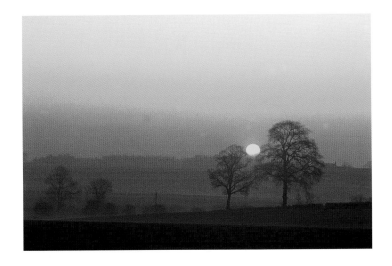

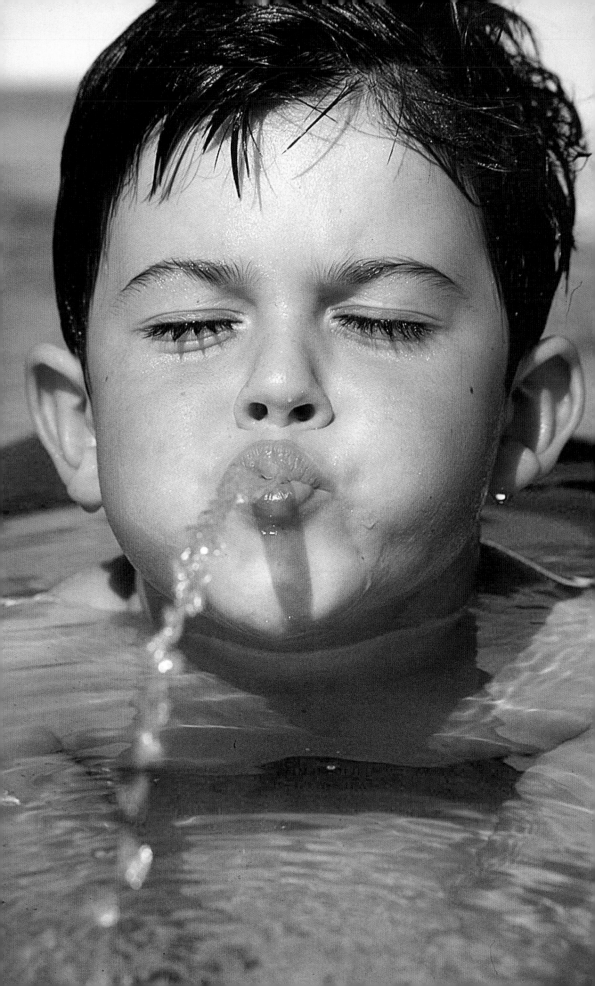

Digital Photography

A no-nonsense, jargon-free guide for beginners

STEVE BAVISTER

C&B

First published in Great Britain in 2000
by Collins & Brown Limited
64 Brewery Road
London
N7 9NT

A member of **Chrysalis** Books plc

Distributed in the United States and Canada by Sterling Publishing Co.,
387 Park Avenue South, New York, NY 10016, USA

3 5 7 9 8 6 4

British Library Cataloguing-in-Publication Data:
A catalogue record for this book is available from the British Library.

ISBN 1 85585 781 2

EDITORIAL DIRECTOR: Sarah Hoggett
EDITOR: Mathew Rake
DESIGNER: Amzie Viladot Lorente

Reproduction by Classic Scan Ltd, Singapore
Printed and bound in Italy by Graphicom srl

Contents

Introduction

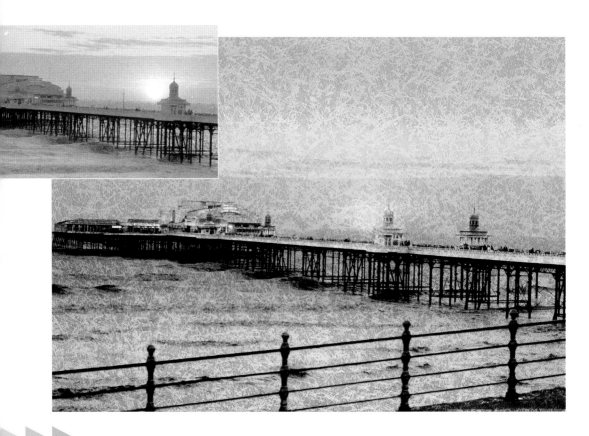

There has never been a more exciting time to be involved in photography.

Although there have been enormous advances in camera and film technology since it was invented over 150 years ago, the process itself has remained virtually the same – with a light-sensitive emulsion being exposed and processed to create the finished photographic image.

But all that has changed with the introduction of digital imaging. The steady pace of evolution has been replaced by a dramatic revolution, and things will never be the same again.

At its simplest, digital imaging is the process by which photographs are 'digitized' so they can be used in a computer. Once there they can be cropped, improved, combined and then used in countless ways that would have been unimaginable before digital imaging came along. Your computer can literally become a digital darkroom – without the horrible smell and the need to black out the windows.

Having let your creative juices flow, you can send the images winging down a telephone line to a relative or friend anywhere around the globe in the wink of an eye, output them as photo-realistic prints on your desktop printer, put them up on a website for all the world to see, or incorporate them into reports, newsletters and presentations.

Getting started

There are also many different ways of getting into digital imaging. One of the quickest and easiest is to use one of the latest generations of filmless cameras which offer quality comparable to that of traditional photography. These allow you to capture the picture using an electronic sensor, review it on a built-in monitor, erase it and shoot it again if you're not happy, and then download it immediately to your computer. Inexpensive to run, these cameras enable you to take many more pictures than you previously might have done, making it easier for you to know

that you have come up with an image that really captures the scene or situation before you leave it.

Or, if you already have a quality camera or maybe a complete outfit, you might prefer to continue taking pictures using film and then digitize them later using an inexpensive scanner. In some ways this route offers the best of all worlds – you still have your negative and print or slide, but you also have all the new imaging opportunities offered by having the photograph in the computer.

Scanners also allow you to digitize your existing collection of images, and it is even possible to undertake projects such as copying and electronically retouching a treasured family photograph or enhancing a favourite picture.

Overall, though, it's the ease, speed, flexibility and creativity offered by digital imaging that make it so powerful and so appealing. And that's what this book is all about.

Starting from the basic principles and the equipment you'll need, it will guide you step-by-step on the path to successful digital imaging.

Better pictures

Although improvements can be made in the computer later, it still makes sense to take as good a photograph as possible in the first place – so in 'Taking Better Pictures' there is lots of practical advice on key photographic techniques such as lighting and composition for many of the most popular picture-taking subjects.

But whatever care and trouble you go to, few pictures are perfect, so Enhancing the Image discusses the many ways in which computer software can allow you to make simple yet profound improvements to your pictures – changing the colour, brightness, contrast and sharpness, and rectifying faults such as red-eye and converging verticals.

Digital creativity

Once you've mastered those techniques you'll be looking forward to even greater challenges, and 'Creative Imaging' offers a wealth of ideas for imaginative projects – from turning your photographs into paintings and adding borders and frames to combining several images in a single composition.

After that, 'Uses of Digital Photography' takes a look at some of the ways in which you might want to use your images – including making a greetings card, creating a website or sending e-mail attachments – with advice on what image format and resolution will work best.

Finally, in 'Next Steps' we consider some of the possibilities that open once you become more accomplished in your image-making, with a gallery of superb images from masters of the art.

But whatever your interest in digital imaging, and however far you want to take it, you'll undoubtedly find the journey fascinating and fulfilling.

The secret, as ever with photography, is to take lots of pictures, try out lots of techniques, learn from your mistakes and do it better next time.

But most of all, enjoy your digital imaging!

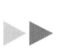

1

Basics and
Equipment

Routes into Digital Imaging

There are many ways to get photos into your computer. The most obvious, and probably the most straightforward, is to buy a digital camera. This works pretty much like an ordinary camera, except that images are downloaded to a computer rather than a film being sent off for processing. Digital cameras continue to improve in specification and decrease in price. Another approach is to keep your existing equipment and invest in a scanner, which allows you to produce digital files from existing prints, negatives or slides. Most people have built up a collection of pictures over the years, and the low cost of buying a scanner now makes it a worthwhile purchase. Beyond these two, though, there are many other options.

Digital camera

Designed specifically for capturing digital images, and therefore one of the basic tools for anyone serious about electronic photography. Resolution levels on the latest models mean that it is possible to produce prints of photographic quality, and increasing levels of specification mean you don't have to miss out on useful features available on conventional cameras.

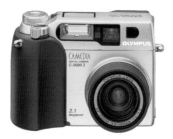

△ **Digital camera**
The easiest route into digital imaging.

Flatbed scanner

A flatbed scanner works a bit like a photocopier – only you end up with a digital file rather than a paper copy. Simply place a photographic print face-down on the glass surface, press 'scan', and within a minute you can save the image onto your computer. Scanners are ideal if you would like to store or amend existing prints digitally. They are also a good investment if you want to continue using a conventional camera.

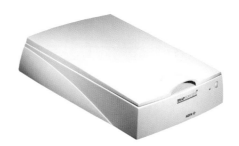

△ **Flatbed scanner**
An inexpensive way of getting started.

Film scanner

Film scanners offer the same benefits as flatbed scanners, but rather than prints they scan negatives or slides. Film scanners tend to be more expensive than flatbed scanners, but have the advantage that you don't need to have prints made first. The resolution is also higher, making it possible to get quality prints from a 35mm original.

△ **Film scanner**
Ideal if you shoot transparencies.

Kodak Picture CD

One of the best alternatives to investing in a scanner or buying a digital camera is to have your pictures scanned for you. Many laboratories now offer a package service in which you get back scanned images on a CD as well as your prints or transparencies. The most popular CD service is Kodak's Picture CD which gives images with a resolution of 1534 x 1024 pixels. This offers excellent value considering you don't have to invest in any hardware. The CD also features various software to help you improve the quality of the pictures.

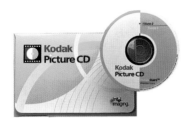

△ **Kodak Picture CD**
Get digital images along with your prints.

Kodak Photo CD

Picture CD is fine for the new pictures you take, but what about the large archive of photographs you've taken over the years? One option is to have them put onto Photo CD – a similar CD-based system, which allows you to have existing pictures scanned. Up to 100 images can be stored on a single Photo CD and, for flexibility, each is saved at five different sizes, from 192 x 128 pixels (ideal for e-mail or use on a web-site) up to 3072 x 2048 pixels (18 Mb images good enough for A4 reproduction). The original images can either be prints or slides. However, Photo CD is more expensive than Picture CD, though some labs do offer discount for larger volumes.

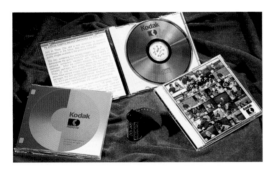

△ **Kodak Photo CD**
High resolution scans from your pictures.

Digital camcorder/VHS tape/laserdisk

Many digital camcorders, used primarily for recording moving images, also have a facility for capturing still images as well. While the quality falls a long way short of what you can get from a digital camera or scanner, it's an option worth considering if you already have a camcorder and don't need large prints of high quality. You can also 'grab' images from normal video cassette recorders and laserdisk players – however, the quality here really is inferior. Depending upon the age of the equipment, you may only need a set of cables, but if not there are reasonably-priced hardware/software packages that allow you to grab images from these types of sources.

△ **Digital camcorder**
A useful source of low-resolution images.

Royalty-free images

If you're interested in creative imaging, then it could be worth investing in a CD-ROM of royalty-free stock images. As the name suggests, you can use the images in any way you like (with one or two exceptions), as if they were your own. There's a huge range of such CDs on offer – usually in themes such as people, medical, business, backgrounds – to meet every need. Check the size of the files carefully before buying. On some of the cheaper CDs the resolution really isn't large enough for serious digital imaging.

The internet

Anyone who's 'surfed the net' will know that there are millions of different images on the web, all of which can be downloaded onto your hard drive at the click of a button. However, unless the images say they are free to be used, you will be violating someone else's copyright by taking them without permission, so tread carefully. Incorporating an unauthorized image into your work is like stealing from someone's photo album.

Computer Requirements

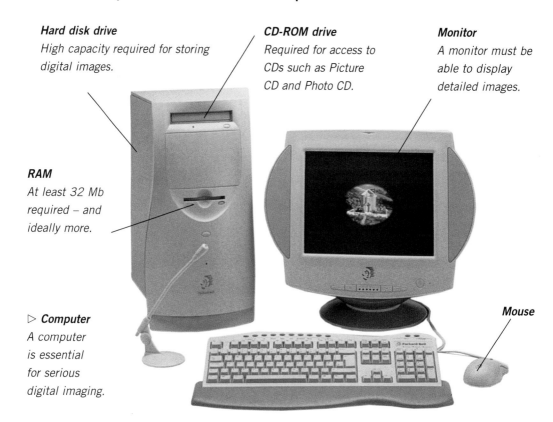

Hard disk drive
High capacity required for storing digital images.

CD-ROM drive
Required for access to CDs such as Picture CD and Photo CD.

Monitor
A monitor must be able to display detailed images.

RAM
At least 32 Mb required – and ideally more.

▷ **Computer**
A computer is essential for serious digital imaging.

Mouse

While it's possible to get involved in digital imaging without having a computer, you'd be extremely limited in terms of what you could do. Obviously you'd need a digital camera to capture the images, but you would then need to buy a printer to which you could connect the camera directly or use a commercial service to print out the images for you. Either way you lose almost all of the control and creativity that make digital imaging appealing in the first place. You may already have a computer and, unless it's ancient, you should find it adequate to get started. Ultimately, though, if you're serious, you'll want a machine configured with electronic photography in mind – working with large digital images requires plenty of memory and a considerable amount of processing power.

Apple Mac or Windows PC?

One of the important things you have to decide is whether to go for an Apple Mac or a Windows PC. Macs

Advantages of upgrading

It certainly makes life easy having as much hardware as possible built-in to your computer, but this does make it more difficult when you want to replace individual components, such as modems and removable drives, when speed or capacity increases. However, the falling cost of computers and overall increase in processing power mean that you're likely to be changing your PC every few years anyway.

have become increasingly popular in recent years and have the advantage of being easy to set up and use. You don't have to add 'extras' such as sound cards, and they're widely used by professionals working in digital

imaging. However, PCs tend to be cheaper, there's a much wider range available, and there's lots more software to choose from. The decision is not an easy one, especially now Macs are being targeted at the home market. Those wanting a computer that will meet general family needs as well should probably go for a PC, while those in earnest about digital imaging should seriously think about getting a Mac.

What to look for

Microprocessor
Also known as the CPU (Central Processing Unit), the microprocessor is the 'brain' of the computer, and the faster it works the better. Speed is measured in megahertz (Mhz), and anything less than 233 Mhz will seem painfully slow, especially with larger images. With every new range of computers the speed increases, and you might be tempted to keep upgrading, but in practice having more memory (RAM) is a better investment.

RAM (Random Access Memory)
The computer should have enough memory to run your image-manipulation software effectively. Most ready-configured machines come with a minimum of 32 Mb of RAM (Random Access Memory), which is sufficient for working on smaller files. But, if possible, you should go for 64 Mb of RAM, and ideally 128 Mb, which will make it easier if you want to work with big images or use heavyweight image programs such as Adobe Photoshop. In practice, the amount of RAM should be three times the largest file you'll work with – so if you want to work with 40 Mb images (which you easily get from a flatbed scanner) you'll need that 128 Mb.

VRAM/graphics card
The amount of VRAM (Video Random Access Memory) you have determines the quality of the on-screen image – and you need a detailed mage on the monitor if you are to do accurate retouching and enhancement. On PCs VRAM comes in the form of graphics cards, with lots of options on the market. You need 4 Mb as a minimum and 8 Mb ideally.

Hard drive
The storage area of your computer is called the hard drive, and its size – measured in ROM (Read Only Memory) – is important as digital files take up a lot memory. 2 Gb of ROM is the minimum that's workable –

and 4 Gb, 6 Gb or 9 Gb is preferable. In time you will probably want to expand your storage options with some kind of removable drive.

Monitor
It's a good idea to buy the biggest monitor you can afford. 17 in (430 mm) is now pretty much standard issue, but if your budget runs to it you should invest in a 20 in (505 mm) screen – ideal for working on large images and having all the tools visible at the same time. Make sure the monitor can display at least 1024 x 768 pixels at 24-bit depth, the minimum for satisfactory retouching.

Ports/expansion
Depending on what's built into your computer already, you may want to add lots of peripherals, so make sure that there are sufficient ports (sockets) to accommodate them.

CD-ROM
Built into all current computers and available as a peripheral for older models. Allows you to access images on Picture CD, Photo CD and royalty-free CDs, as well as installing enhancement and manipulation software.

Modem
With the increasing popularity of the internet more and more computers feature an integral modem – allowing you to use e-mail and 'surf the net'. You will need one if you want to share your images via e-mail or set up your own website.

Removable storage
Most PCs still have a slot for floppy disks, but these are gradually being replaced by higher capacity options such as Zip or DVD (Digital Versatile Disk). Some now even feature a CD-writer, allowing you to store your images on CD disks.

Choosing a Digital Camera

The quickest and easiest way of getting into digital imaging is to buy a digital camera. The advantages are obvious: you don't need to keep buying film, the images are already in a digital format, you can see the results immediately, and downloading images to the computer is relatively straightforward. While early digital cameras were of an inferior standard, the latest models compare favourably with their conventional rivals – and quality is improving all the time. On a practical level, digital cameras also have a lot going for them. Most models feature a built-in LCD monitor which allows you to check the picture you've taken and, if you're not happy with it, erase it and shoot again. This means you'll probably end up with fewer images of a much higher standard.

Buy now or wait?

The technology in digital cameras is developing rapidly, and you can be sure that next year's models will produce better-quality images and have more features than those on the market today – and probably at a lower price to boot! Does that mean it's better to wait? In a word, no. Because next year you'll find yourself in the same predicament, with new and improved models just over the horizon. So don't delay: when you feel ready for a digital camera, go out and buy one.

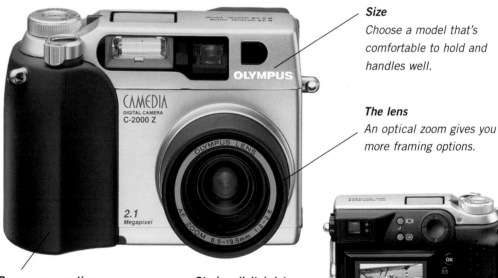

Size
Choose a model that's comfortable to hold and handles well.

The lens
An optical zoom gives you more framing options.

Power consumption
Limit use of monitor and zoom to maximize battery life.

Storing digital data
Removable cards are used for storage.

△ **The digital camera**
A digital camera is the quickest and easiest way of getting into digital imaging – with high-quality results now achievable.

What to consider

Digital cameras come in a wide range of specifications and prices, so you need to think carefully about what your needs are before parting with your hard-earned cash. These are the kind of issues you should be considering when you come to make a purchase:

- what resolution do you need?
- is a fixed lens sufficient or will a zoom be required – and if so, what range?
- which is the most suitable removable storage system?

The lens

Many digital cameras feature a fixed lens with a slightly wide-angle focal length. However, it's worth spending a little extra for a zoom lens which allows you more versatility in framing the subject. As a rule of thumb, you can multiply the focal length of the lens by seven to get the equivalent lens in 35mm terms. So a typical digital lens of around 6mm lens will be around 42mm.

Size matters

Digital cameras vary enormously in their size, and smallest isn't always best. Handle several models before making a choice.

LCD monitor

Virtually all digital cameras now have a colour LCD monitor which shows you what the lens is seeing. It also allows you to check images already captured and delete them if you don't like them. Some screens are difficult to view in bright light, so check before you buy. Some models have an optical viewfinder in addition to a LCD monitor, which makes them more versatile.

Power source

If you use the LCD monitor, flash or zoom regularly, your digital cameras will consume a lot of power – and get through batteries at an alarming rate. For that reason many manufacturers are now supplying cameras with rechargeable cells, and these are definitely a worthwhile investment.

Image quality

One of the key factors in image quality is resolution, which is indicated by the number of pixels captured by the CCD (see below). The more pixels, the better the picture. Technology in this area is constantly improving, but most of the models available now deliver more than acceptable quality.

Output sockets

These allow images to be downloaded via a cable to your Windows PC or Apple Mac – though using a card reader (see p.19) is a faster option. On some cameras you can also show the pictures you've taken on a normal television set or produce hard copies by means of a direct connection to a printer.

Removable storage

Images are captured onto removable storage cards which act like 'digital film', and can be wiped clean once the pictures are on the computer, and used over and over again. The number of pictures you can store depends upon the amount of memory in the card and the resolution of the images. Investing in a higher-capacity card allows you to take more pictures when you're away from your computer.

Exposure/flash

Most digital cameras are fully automatic, taking care of exposure for you – though some models do offer an over-ride should you need to tweak the results. Usually there's a built-in flashgun which fires as and when required, once again with some degree of user control.

What is a CCD?

Digital cameras record images differently to conventional cameras. The image is captured by a CCD (Charge-Coupled Device). This has a rectangular array of light-sensitive picture elements (pixels) which produce an electrical charge proportional to the amount of light that falls on them. Each pixel is a tiny part of the picture, and the total number in the array determines the resolution of the final image.

How Digital Images are Made Up

Changing from conventional photography to digital imaging means that your unit of currency changes too. Whereas film-based pictures are made up of tiny grains of silver halide, digital images consist of minute squares of colour and brightness called picture elements – or pixels. In simple terms, the more pixels you have the more detailed the image will be – which is why the resolution of digital cameras and scanners is all-important.

The number of pixels you have determines the sharpness and detail in the image, whether you view on screen or print it out. The more you blow up the image, the more visible the pixels themselves become. If you go too far, the image will 'pixellate' and look unsharp. Having 'surplus' pixels in an image means that you can, if you wish, enlarge it without any loss of quality.

How pixels make up a digital image

When you digitize an image, it's rather like placing a wire mesh over it and analyzing the brightness and colour of each square. Here's what happens as you increase the number of pixels.

1 x 1 pixel resolution
If you take a typical picture and integrate all of the colours and the brightness, this is what you get – a 1 x 1 pixel image.

2 x 2 pixel resolution
Once you get up to four pixels, you can begin to see variations in the colour and brightness – but little detail.

4 x 4 pixel resolution
Move up to 16 pixels and more tonality starts to emerge – though it's still not possible to recognize the subject.

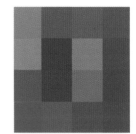

8 x 8 pixel resolution
With 64 pixels visible there's much more variation in colour and brightness, but we still can't see what's happening.

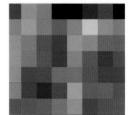

16 x 16 pixel resolution
Now we have 256 pixels to play with shapes are starting to appear, but they continue to lack clear definition.

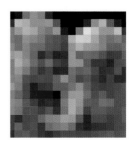

32 x 32 pixel resolution
At last the subject starts to reveal itself – though it's really not possible to recognize the subjects fully.

64 x 64 pixel resolution
Once you get to 64 x 64 pixels, a total of 4,096, the people are more clearly defined – but the effect is a little coarse.

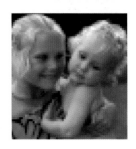

128 x 128 pixel resolution

Not exactly photographic quality yet, but having 16,384 pixels (a 48 Kb image) begins to look acceptable.

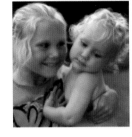

256 x 256 pixel resolution

Now a 192 Kb image containing 65,536 pixels, the image looks sharp and clear, with no individual pixels visible.

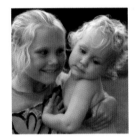

512 x 512 pixel resolution

A 512 x 512 resolution gives 250,000 pixels, a 758 Kb file, and an image of photographic quality at modest size.

Understanding resolution

There's often confusion, even among experienced digital-imaging enthusiasts, about resolution. The complications seems to arise when photographers try to link the input resolution, from a digital camera, scanner, CD etc, to the output resolution requirements of an inkjet printer, computer monitor or reprographics company.

Input resolution

On most digital cameras and scanners you can usually control the resolution of image capture, and there's no sense in setting a higher resolution than is required (see below) – you'll only end up with lots of large files that you'll have to store. However, while you can always throw pixels away later without loss of quality, trying to add them generally leads to inferior results.

Output resolution

Once the picture has been saved onto the computer you can open it in your image-manipulation program and, if necessary, adjust the resolution according to the intended use. This will change the image size, making it smaller if resolution is increased and larger if resolution is decreased. Below is a guide to output resolutions in dpi (dots per inch).

Which resolution?

Deciding which resolution to save an image at depends on what you eventually want to do with the picture. Here are some examples of types of usage and the appropriate output resolutuion:

USE	RECOMMENDED OUTPUT RESOLUTION
Screen use, eg website	72/75 dpi
Inkjet printer (360–1440 dpi)	140–240 dpi
Reproduction in magazine/book	260–340 dpi

Transferring Images to a PC

Having captured an image with a digital camera, the next stage is to transfer it to the PC. With early models you didn't have any real choice about how to transfer images from the camera to the computer. As the pictures were stored in memory built into the machine, the only way to get them out was down a serial cable plugged into the back of the PC. But that can take some time, which is why digital-imaging companies have come up with other ways of taking the image from the camera to the computer. The most successful solution to the problem has been removable media, which can be taken out of the camera and either put directly into the computer, or alternatively into a card reader connected to the computer.

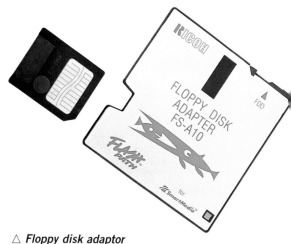

△ **Floppy disk adaptor**
The most convenient option for users of SmartMedia cards.

Downloading via serial cable

Dowloading images by means of a cable is something that anyone with a digital camera and personal computer can do. The first thing you have to do is install the software. This is usually provided on a CD, and takes just a few minutes to set up. Then it's a simple matter of connecting the cable to the appropriate in/out sockets and setting the software to download. However, as anyone who has tried will know, it can take a long time to transfer a batch of images. This is especially true with modern high-resolution cameras, tying up the camera and computer for long periods of time, and leaving you pulling out your hair in frustration. You should make sure that your camera batteries have sufficient energy in them – or connect the camera to the mains – to avoid your camera shutting down halfway through downloading the images.

Storage media

There are several rival systems of removable storage – which you use depends on your camera. These are the major systems in use right now.

Floppy disk

The humble floppy disk is an obvious form of removable media. It has the advantage of being inexpensive and readily available, and you can put it straight into the computer. Sony, with its Mavica range, is currently the only company producing floppy-based digital cameras. However, storage capacity is severely limited, which means that images either have to be of relatively low quality or heavily compressed, and of course there's no room for expansion.

To access the images, simply insert the disk in the floppy drive of your computer.

SmartMedia

Developed in Japan by Toshiba, SmartMedia is the thinnest form of storage available, measuring $1\frac{3}{4}$ x $1\frac{1}{2}$ x $\frac{1}{24}$ in (45 x 37 x 0.76 mm) – the same thickness as a credit card, but only two-thirds the size.

Megabyte for megabyte, SmartMedia is considerably cheaper than CompactFlash – but right now has a more limited maximum storage capacity. SmartMedia cards can be inserted into the PC's floppy drive by means of a handy device called a FlashPath adapter. The card then appears on the computer desktop as a folder, giving you immediate access to the images. FlashPath is powered by two small lithium batteries. Images can also be accessed via a card reader (see opposite).

CompactFlash cards are too thick to go into a floppy drive, so the convenient way of accessing them is via a card reader.

Card readers

Investing in a card reader takes a lot of the hassle out of digital photography. All you have to do is connect the reader to the PC and then drop in the card. Some units take SmartMedia or CompactFlash only, but increasingly they accept both.

Most readers are also 'hot-swappable', which means that cards can be inserted and removed while the computer is switched on. The images appears as a folder on the desktop, and it takes just a few seconds to open up each one.

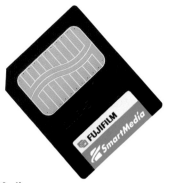

△ **SmartMedia**
A slim and compact storage option.

CompactFlash

CompactFlash is currently the most popular removable media platform, supported by a large proportion of the leading manufacturers. The memory cards measure $1^{11}/_{16}$ x $1^{3}/_{8}$ x $^{1}/_{8}$ in (43 x 36 x 3.3 mm), and are strong and stable. As solid-state devices, with no moving parts, they can withstand a drop of 10 ft (3 m), operate at temperatures from 13°F–167°F (-25°C–75°C), and can typically be used for more than 100 years with no loss or deterioration of data.

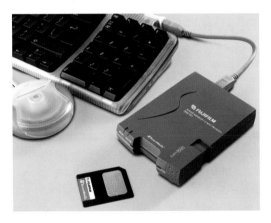

△ **Card reader**
Saves the frustration of cable downloading.

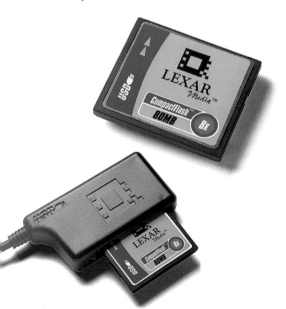

△ **CompactFlash**
A stable, long-lasting and popular removable storage medium.

Downloading

Before you start to download images from your camera, delete any that you no longer want. This will save you time and conserve your camera's power supply.

Choosing and Using a Scanner

A popular way of getting images into a computer is to use a scanner. This works in a similar way to a photocopier or fax, and allows you to convert existing prints, slides or negatives into digital files. This is ideal if you have a large collection of pictures already, or have made a significant investment in film-based cameras that you're not yet ready to give up. Scanners connect directly to the computer and are easy to use once the software has been installed. There are two types of scanners: flatbed scanners work with prints, while film scanners are ideal for negatives and slides. (Some flatbed models have optional hoods for scanning negatives and slides.) Scanners are now relatively inexpensive, and worth buying even if you mainly use a digital camera for taking pictures.

Flatbed scanners

There are dozens of flatbed scanners on the market, so you should have no difficulty in finding one that meets your needs. Paying more does not necessarily mean you'll get significantly better quality – unless you're a professional working to demanding standards. Most flatbed scanners let you convert prints up to A4 (letter) and slightly larger to digital files, which means, in photographic terms, you can scan up to an 8 x 10 in

(200 x 255 mm) image – 10 x 12 in (255 x 305 mm) on some machines. Units that scan up to A3 – 11⁷⁄₁₀ x 16⅕ in (297 x 420 mm) – are available, but cost considerably more. On flatbed scanners you will often see two resolution figures, representing the length and width of the scan. For most practical use, reasonably priced 600 x 1200 dpi machines are perfectly adequate – allowing you to increase the size of an image from say 6 x 4 in (150 x 100 mm) to A4 (letter).

Transparency adapter

On many flatbed scanners you can get an optional transparency adapter, sometimes also known as a hood. With this, the light shines through the image rather than reflecting back from it. Despite the name, this can be used for both transparencies (slides) and negatives. It's an attractive proposition, but in practice the quality you get from 35mm originals is less than satisfactory and not really good enough for serious digital imaging, though photographers with medium-format equipment may find the resulting scans acceptable for certain uses. The ideal solution is to invest in a dedicated 'film' scanner.

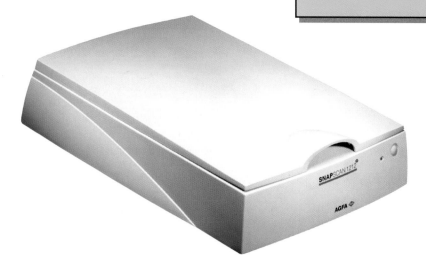

◁ **Flatbed scanner**
Works like a photocopier and produces high-quality images from prints and flat artwork. A flatbed scanner is relatively inexpensive and an essential purchase for the digital imager.

Film scanners

As the name indicates, film scanners let you work with transparent rather than reflective originals – that is, slides and negatives. Most reasonably priced machines are designed for use with 35mm and APS (Advanced Photo System) films. You can usually load images individually, in mounts or as strips. With slide/negative scanners, the resolution needs to be higher than with flatbeds, as the originals are so much smaller. Most current models offer a resolution around 2700 dpi, which will allow you to print out a scanned 35mm image to around A4 (letter). Slide/film scanners for medium-format originals are available, but the price is several times that of 35mm/APS units.

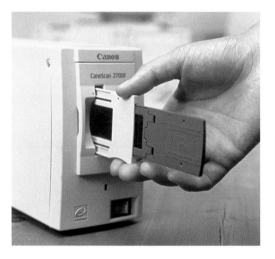

△ *Film scanner*
The best choice for transparency users.

Things to consider

Resolution – this indicates the amount of detail you can capture from an image, and as with digital cameras the higher the resolution the better. Resolution is usually indicated in pixels per inch (ppi).

Colour depth – make sure the scanner is at least '24-bit', which means it is capable of resolving at least 16.7 million colours. You will see higher figures advertised, but unless you are using the scanner professionally, there is little advantage to be had.

Interpolation – some manufacturers inflate their resolution figures to sound more impressive – so you may see a flatbed scanner advertised as offering up to 9600 dpi. This indicates that the scanner and software can 'improve' resolution by a process called interpolation, which adds pixels to the image. Often the results using interpolation are poor, so true optical resolution is preferable as a guide to expected quality.

Connections – the way in which scanners connect to computers has changed over recent years, with USB (Universal Serial Bus) becoming more common than SCSI (Small Computer Systems Interface) connections. Check before buying that everything is fully compatible.

Software – all scanners come with basic capture and enhancement software, but some come with a whole bundle of packages. Some film scanners feature proprietary software that removes dust and scratch-marks, which can save lots of time in retouching.

Scanning techniques

Scanning resolution: Unless images are required for e-mail or the Internet, you should generally scan at the maximum optical resolution, and then, if necessary, reduce the file size later.

Preparing the image: Always start by making sure the print, slide or negative is as free from dust, hair or scratches as possible – or you may have to spend considerably effort in cleaning the digital images up afterwards.

'Preview' scans: Your software will usually start by giving you a 'preview' scan. This is your chance to crop the image and make any corrections to brightness and contrast.

Saving images: Start by saving the image in a high-resolution format, such as TIFF, rather than a 'lossy' format, such as JPEG.

Printing Your Images

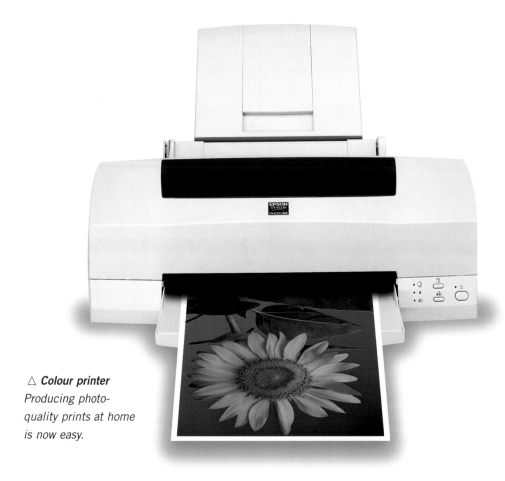

△ **Colour printer**
*Producing photo-
quality prints at home
is now easy.*

While a handful of people might be content just to view their images on their computer monitor, most of us also want to make prints that we can take around to show to family and friends, or which we can frame or put in albums. Thanks to the introduction of affordable colour printers, getting high-quality hard copy from your digital files is quick and easy – and the printers can be used for text documents such as letters and reports as well. On the practical front, connecting the printer to the computer is increasingly straightforward, and you should be up and running within minutes of getting one home from the shop. If you don't want to buy a printer, there are a growing number of commercial services that will do the job for you.

Choosing a printer

**Things to consider when buying a
printer for digital imaging:**

- is it capable of photographic-quality output?
- can you use a wide variety of paper types?
- what is the cost of replacing the ink cartridges?
- is A4 (letter) big enough, or do you need A3 – $11^7/_{10}$ x $16^1/_5$ in (297 x 420 mm) – format?
- what is the maximum resolution available?
- does it produce crisp black text as well?

Output resolution

It's essential when buying a printer for digital imaging that you choose one with the highest resolution you can afford – that way, the finished print will be as

close as possible to true photographic quality. However, there is often confusion about the resolution of the image in relation to the resolution of the printer. Some imaging enthusiasts think that they have to be the same, but this is not the case. Always check with your instruction manual, but for a typical 1440 dpi (dots per inch) inkjet printer the output resolution should be around 240 dpi. There is no harm in using a higher resolution, although the printing time may be longer, but at a lower resolution the image will start to pixellate.

Special printing paper

Although you can use plain paper in most colour printers, you really need to use special 'inkjet media' if you want to get the best possible quality. This is now available from many different manufacturers in a bewildering range of types and finishes, allowing you to choose exactly what you want for the job in hand. For everyday use a standard weight (80 gsm) paper is ideal, but for something more important a heavier card is preferable. Most of the inkjet paper available has a glossy finish, but other types are available, including matte, textured and canvas finishes. It is also possible to use watercolour paper, available from an art shop.

Matching the print to the monitor

One of the hardest parts of digital imaging is matching what you see on the screen to the finished print. There are good reasons for this: the screen image is illuminated and made up of red, green and blue (RGB) light, while the print is made of cyan, magenta, yellow and black (CMYK) inks and dyes. It's worth spending some time initially in calibrating the printer and monitor so they match each other as closely as possible.

Dedicated printers

Not everyone interested in digital imaging has access to a computer, so there are also printers that you can plug directly into the camera or which are designed to accept removable storage cards. Press 'print' and within seconds a photo-quality print is on its way. On some models, you can specify up to 16 images on an A4 (letter) page, and even crop or enlarge images before printing. Some can also be connected to a Zip drive for storage.

Making prints last

Not all of the inks and dyes used in inkjet printers are stable, with the result that images can sometimes fade if displayed in daylight. Whenever possible, therefore, and certainly with prints that you would like to be around for some time to come, it's worth investing in special inks that are guaranteed for 75 years – though it will also depend upon the kind of paper you print on, because some paper will last longer than others.

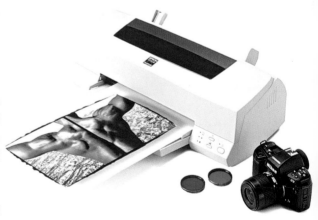

△ **Printing paper**
To maximize quality,
use special inkjet
media (papers).

Storing and Cataloguing Images

▶▶▶ Once you get involved with digital imaging, you may discover that what once seemed like an enormous hard drive is actually not that big at all. That's because high-resolution images take up a lot of storage space. A typical A4 (letter) quality image will be somewhere in the region of 10–15 Mb – and 100 such images fill a 1 Gb (gigabyte) drive. Once you get into multi-image montage work, file sizes can become even larger than that, and you may want to save a number of variations of the final image, along with 'work in progress' along the way. For that reason it's virtually essential to invest in some additional storage – which also has the advantage of allowing you to share your work with others. Here are some of the most popular storage options.

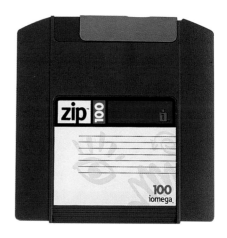

△ **Zip disk**
One of the most popular ways of storing and sharing high-quality images.

Additional hard drive

This works in exactly the same way as the hard drive on your computer, and with prices having tumbled in recent years this is now an affordable option worth considering. Popular configurations are 9 Gb and 18 Gb, which will hold a considerable volume of even high-resolution images. A second hard drive is also a good way of backing up important files should your main hard drive crash.

Zip/Jaz

Zip cartridges have replaced the original floppy disk as the most popular removable storage medium. Initially offering 100 Mb of storage per cartridge, the capacity has now been increased with a 250 Mb option. Both the drives and the disks are reasonably priced, and their widespread use means that it's easy sharing images with others or taking them to a lab or bureau to get a print. Jaz cartridges are an excellent choice for those generating lots of large files. Jaz offers a choice of 1 Gb or 2 Gb of storage on one removable cartridge – and though the cartridges themselves are relatively expensive, the cost per Mb of storage is extremely economical.

Optical/DAT

More widely used in the graphics industry, Optical disks and DAT (Digital Audio Tape) cassettes offer unlimited storage and, compared with some of the other removable media, a minimum risk of data loss. For most home users, though, Zip is a much better alternative.

△ **DAT cassette**
Along with Optical disks, DAT is widely used by graphics professionals.

CD writer

As they hold an enormous 650 Mb of information and yet cost very little, CDs are one of the best storage options for finished images. To put an image on a CD you need a CD writer – and these are also competitively priced now. The only drawback with CDs is that they are not very flexible, as you can only write images on a standard CD once. You can buy CD-RW (Read Write) disks which allow you to write repeatedly but these are considerably more expensve.

◁ **Compact dlsk**
With a storage capacity of up to 650 Mb, the compact disk offers cost-effective storage for completed images and projects.

Using compression to save space

If your interest in digital imaging means that you're generating so many pictures that storage starts to become a problem, you might want to consider compressing them to reduce the file size. Saving them in a JPEG format (see below) is a popular way of saving storage space, but there is some loss of quality if you compress them too much. If that is not enough, check out some of the commercial compression utilities available. It could work out a lot cheaper than continuing to invest in removable media.

File types

FILE	DESCRIPTION
TIFF	High-quality image format, but requires maximum storage space to maintain full quality.
JPEG (JPG)	Most common way of saving storage space – little loss of quality at normal compression ratios.
GIF	Often used for web pages, but loses too much data if you want to bring your image back to a high quality.

2

Taking Better
Pictures

Shoot when the Light is Right

In a very literal sense, light is the 'raw material' of photography – just try taking a picture without it! And that's equally true whether you're shooting digitally or with a film-based camera. But light varies enormously, in terms of colour, intensity and contrast, and successful picture-taking depends upon taking this into account. Some photographers only think about using their camera when the sun is out. However, while bright, contrasty light is perfect for many kinds of photography, other conditions are more suited to other subjects. Portraits, for instance, benefit from soft, overcast light. In fact, there's no such thing as 'bad' light – it all depends on the subject you're taking and the effect you're trying to achieve.

▽ **Bright sunlight: bold colours**
For bold, strong subjects that have vibrant colours, there's nothing like bright sunlight to bring them to life.

▽ **Stormy weather: dramatic lighting**
Some of the most dramatic lighting you'll find is just before and just after a storm. Work fast, though, as it can come and go in just seconds.

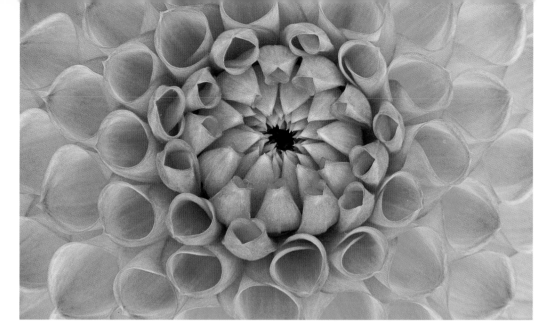

△ Soft lighting: detailed subject

To preserve as much detail as possible, it's best to use the diffuse lighting you get on an overcast day. Avoid bright sunlight, which is often too contrasty.

▷ Rainy days: splashes of colour

Don't put your camera away just because it starts to rain. Choose a subject with bright colours, and you'll find the resulting pictures have plenty of 'bite'.

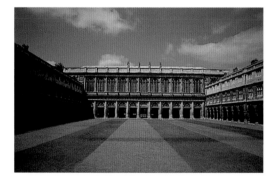

△ Sunny with clouds: great skies

Architectural shots (and indeed landscapes) can look bland with pure blue skies, and better photos can often be taken with a few clouds to add interest. On more sophisticated film-based and digital cameras, you can fit a polarizing filter, as here, to deepen the colour of the sky.

▷ Cloudy and overcast: muted tones

For a muted, harmonious colour composition, choose a day with plenty of cloud. It's also an ideal time to take portraits outdoors.

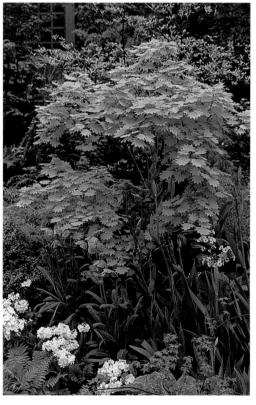

Powerful
Composition

When you see something that is worth photographing, what do you do? Simply lift the camera to your eye and fire off a few frames? Or do you think carefully about how to compose the subject to its best advantage?

Many photographers place their main subject or the horizon slap-bang in the middle of the photograph – producing dull, predictable results. Of course, one of the great things about digital imaging is that you can improve things later on, but even so it's worth following a few simple 'rules' that will improve your success rate enormously and really make your pictures stand out from the crowd.

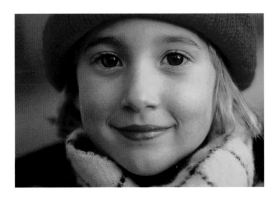

△ *Filling the frame*
One of the easiest ways of generating more impact in your pictures is to fill the frame with your subject – either by going in close or by using a telephoto setting from further away.

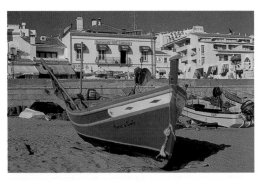

◁ *Dynamic diagonals*
Here the photographer began by including the whole scene, with the colourful boat shown in front of the Spanish buildings (above left). While it's a good composition, it lacks impact. So to create a more dynamic effect, a closer viewpoint was chosen, and the camera tilted to give a diagonal framing that is far more dramatic and instantly eye-catching (below left).

▽ *Rule of thirds*
Imagine your picture divided into thirds – horizontally and vertically. Placing the subject on one of these thirds helps create a balanced composition.

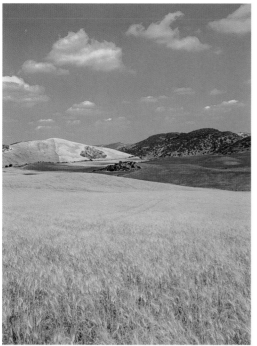

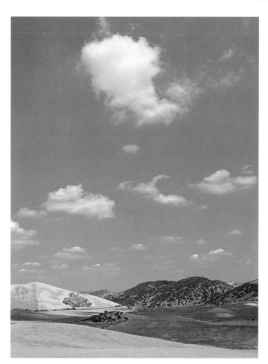

△ **Placing the horizon**

In landscape photography, one of the key decisions is where to position the horizon. Place it near the middle of the frame (above left)

and you have a composition that is balanced but perhaps a little static. Moving the horizon up or down (above right) tends to produce a much more dynamic result.

Be imaginative!

As well as your 'standard' shot, use a few more frames to experiment with different compositional ideas – it will give your work more variety.

▷ **Lead-in lines**

Lines starting from the bottom of the picture and travelling through it are an excellent way of leading the viewer's eye into the shot. Here, the water leads the eye to the main subject of the picture – the building.

Getting Sharp Results

The starting point in photography has to be getting sharp results. Unless you're going for a deliberately 'arty' image, an out-of-focus or badly blurred photo is really only fit for the bin.

Despite all of the 'sharpening' technology that's currently available in image manipulation and enhancement packages, the truth is you'll never achieve the same quality as you would have if you'd recorded it sharp in the first place. The secret lies in careful focusing and using a fast shutter speed. (The better film-based and digital cameras allow you to set exactly the shutter speed you want.) Also, try to use some support such as a tripod – or a convenient wall!

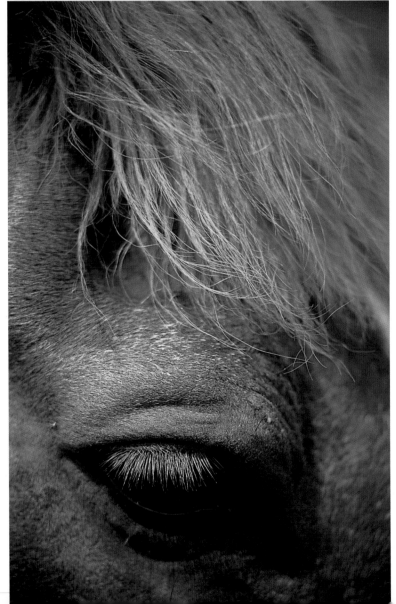

▷ **Pin-sharp perfect**
Just how sharp are your camera lenses, and exactly how good is your photographic technique? A subject such as this will let you find out. Here, thanks to accurate focusing, an expensive macro lens and careful hand-holding at a shutter speed of $\frac{1}{500}$ sec, every detail in the horse's eyelashes is visible.

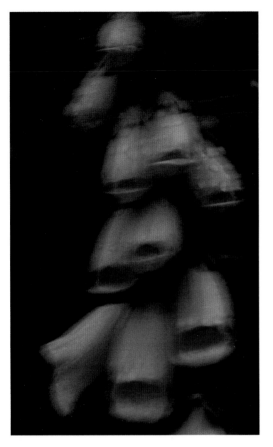

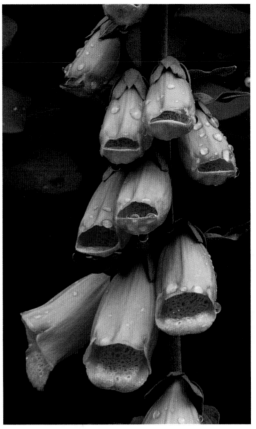

△ **The effects of camera shake**

The above pictures show how devastating the effects of camera shake can be. Taken under overcast conditions, the image on the left was taken at a supposedly 'safe' shutter speed of

$\frac{1}{60}$ sec – but is badly blurred. The photograph on the right was taken at the same shutter speed but with the camera mounted securely on a tripod. The result is a pin-sharp picture, with every detail clearly revealed.

Set a fast enough shutter speed

If you're hand-holding the camera, you need to set a shutter speed fast enough to prevent camera shake. It should be at least the same number as the focal length of the lens in use. So if you're using a 250mm lens on a conventional SLR, you need to set a shutter speed of at least $\frac{1}{250}$ sec.

• Wide-angle lens – minimum of $\frac{1}{30}$ sec shutter speed

• Standard lens – minimum of $\frac{1}{60}$ sec shutter speed

• Telephoto lens – minimum shutter speed of 1 divided by the focal length of the lens in use, so for a 200mm lens you will need to set a shutter speed of at least $\frac{1}{200}$ sec

Using Colour

Taking conscious control of the way in which you use colour in your photography is a key way of improving your picture-taking skills. Don't just let colour be an incidental part of your images – make it the whole point.

Keep your eyes peeled for bright, vibrant subjects that just beg to be photographed, not to mention delicate, muted scenes that are perfect for more harmonious compositions. And remember that the picture you take is only the starting point. Once the image is in the computer, you can increase or decrease the saturation and hue, or even completely alter the colours – so try to think about the potential in a scene as well.

▷ *Monochromatic*
While featuring lots of different colours in a picture can obviously work well, it can be even more effective to reduce your 'palette' to just one or two colours. Such shots often have an intensity and sense of harmony that is lacking in more conventional colour compositions.

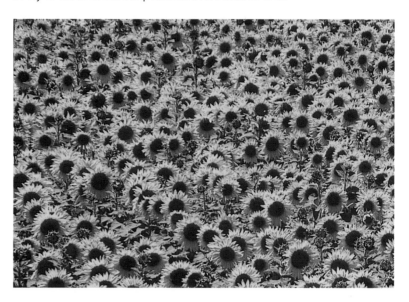

◁ *Primary colours*
Primary colours – red, yellow and blue – can always be relied upon to make an impact, especially when combined with sunlit conditions. And using all three together in a single shot, as here, makes a very vibrant image. The tight cropping created by a telephoto lens adds to the power of the shot.

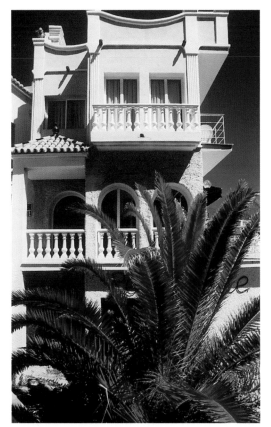

◁ **Infrared film**
For surreal colours,
use Kodak's infrared
slide film in a normal
camera, then play with
the hues further in
your computer.

△ **Vivid colours**
Choose subjects that
have strong, saturated
colours, such as these
crayons lit by window
light, and you're sure
of a vivid picture.

▽ **One small splash of colour**
Think about using colour in a controlled way.
A small splash of vibrant colour has great
impact against a muted background.

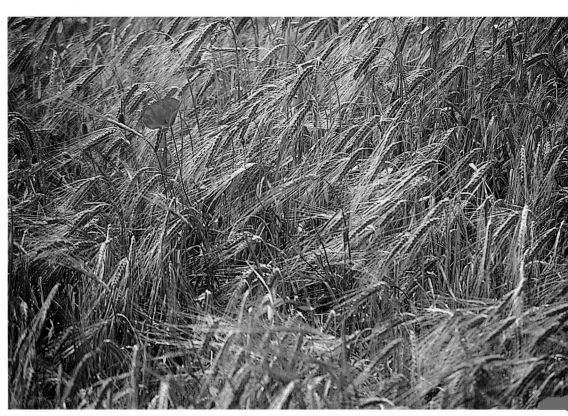

Exposure Accuracy

If too much light gets onto the film or CD, then a picture will be overexposed and washed-out; if not enough light gets onto them, then the image will be dark and underexposed. These days it's often possible to remedy the problem of under- or overexposure in the computer. But the quality is rarely as good as it would have been had the image been captured correctly.

The pictures opposite show the difference that altering the exposure on a conventional SLR can make to the final picture. However, most digital cameras are automated to such a degree that you cannot really control the exposure.

◁ **Dark subject**
Subjects that have a preponderance of dark tones can mislead built-in meters into over-exposing. This results in grey, washed-out images. Reducing exposure, as here, will give a more accurate result with richer dark tones.

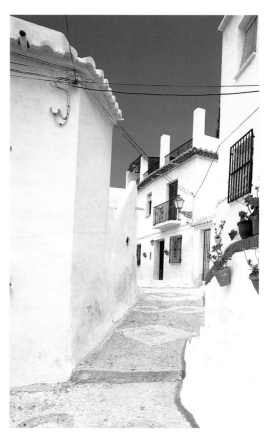

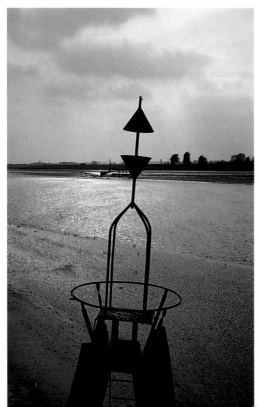

◁ **Into the light**
Care is needed when shooting into the light. Rely on the built-in meter and you'll end up with a silhouette – is that what you want?

△ **Light subject**
Light subjects can cause meters to underexpose. Increasing exposure, as here, ensures the whites stay white!

△ *Plus 1 stop – a little too light*

△ *Plus 1½ stops – much too light*

△ *Minus 1 stop – a little too dark*

△ *Minus 1½ stops – much too dark*

△ *Correct exposure*

Shape and Form

Everything has a shape, and everything has form – and both can be used to produce interesting images. Shape refers to the two-dimensional outline of your subject, while form is the term to used to describe the three-dimensional nature of it. In photography you can emphasize either.

If you shoot subjects with a clear and reconizable outline against the light, you'll get great silhouetted shapes. And if you get in close and shoot with an extreme wide-angle lens, you'll really bring out the form of your subject.

▽ *Irregular shapes*
The shape of a bowler hat is instantly recognizable – and the curves of the rim and top provide pleasing visual 'echoes' of one another.

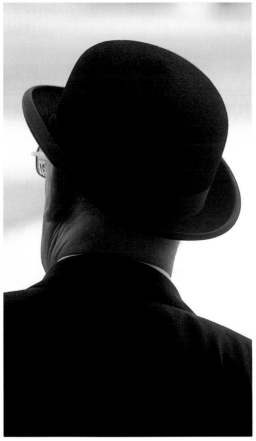

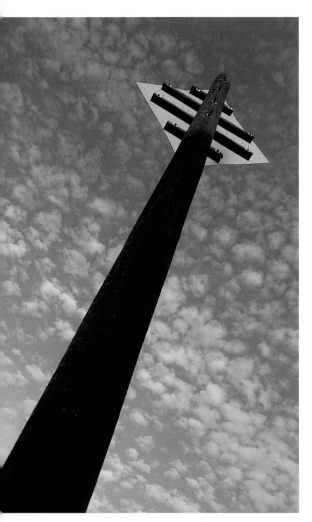

△ **Dynamic shapes**
Clean, graphic shapes can always be relied upon to produce dynamic images – as here, where a wide-angle lens was used to produce a dynamic diagonal composition.

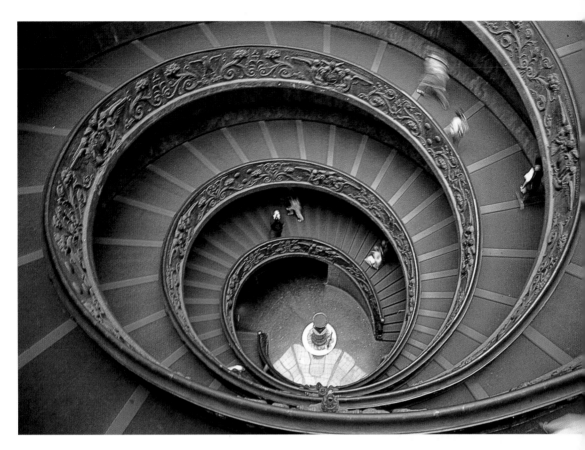

△ *Circular sequence*

Form is emphasized here, as the eye is led into the picture by the spiral staircase. Look out for subject matter that dramatically recedes into the distance – it will help you guide the viewer's eye through the picture.

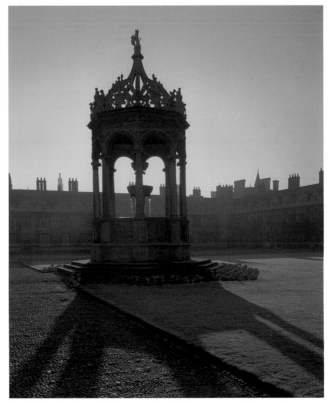

▷ *Stunning silhouettes*

Shooting into the light is a great way of revealing shape – but it only works if you first have a subject with a graphic outline, such as this ornate piece of architecture. To achieve a silhouette effect such as this one, you need to take your exposure from the bright background rather than the subject.

Focusing Accuracy

The automation of modern cameras, both digital and conventional, has made them extremely easy to use – so much so that many photographers imagine them to be foolproof. But if they're not used with thought and care, they can spring a few surprises, particularly when it comes to focusing. Always make sure that the important part of the subject is in focus, particularly when using an autofocus camera.

Manual-focus cameras are less common these days, and rare on the digital front, but still need careful use. Many have a split-screen centre spot, and you should make sure the images in the two halves line up with each other.

◁ **Telephoto lenses**
When using telephoto lenses, you have to be totally accurate with your focusing. Whether your subject is animal or human, always try to focus on the eyes.

▽ **Large aperture**
A large aperture, f/4 or f/5.6, separates the subject from the backdrop, but means that care is needed to ensure that the focusing is just right.

Get the sensor spot-on

Autofocus (AF) cameras can work with incredible accuracy if they are used correctly, but you do need to make sure that the focusing sensor, which is usually in the middle of the viewfinder image, falls over the important part of the scene. If that's not in the centre, then you'll need to compensate.

△ **Between the heads**
A nice shot, but out of focus, because the camera's focusing sensor has fallen on the background between the heads.

◁ **Using the focus lock**
By placing the focusing sensor over one of the heads, holding down the shutter release/focus lock, and recomposing the shot, you'll get a sharp result.

Focus with care

Using a large aperture, such as f/4, will result in a shallow depth of field, which means that only part of the subject will be in sharp focus. However, if you focus with care the effect is dramatic – with accurate focusing the subject will be sharp and will stand out three-dimensionally (see left).

△ **Shooting close-ups**
Focusing accuracy is particularly important with close-ups, where the depth of field (zone of sharpness) is extremely limited.

Points of View

The position and angle from which you take any picture is crucial to its success, and whenever possible you should spend some time checking out the best vantage points before you start to fire away.

Many pictures are taken with the camera about 2 m (6 ft) off the ground – simply because that's how tall people are. But a good way to add variety to your photography is to use vantage points that are higher or lower. At its simplest, this can mean crouching down or clambering up a convenient wall. For the more adventurous, it can involve making your way to the top of a tall building or going potholing.

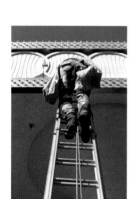

△ **Tipping back**
Simply tipping your head back to point the camera up allows you to capture a different perspective.

▽ **Looking up**
Crouching down (or even lying flat on your back) enables you to point the camera straight up – ideal for architectural interiors, such as this shot taken with a wide-angle lens. A small aperture helps to keep everything in sharp focus.

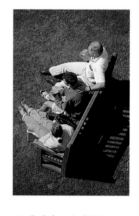

△ **Gaining height**
You don't need to get far off the ground to see things differently. Just climbing a wall is a good way to start.

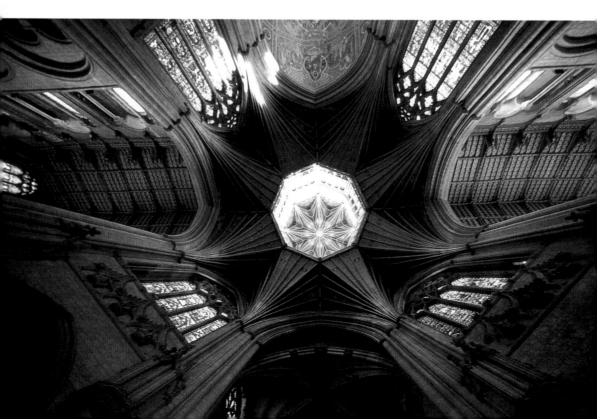

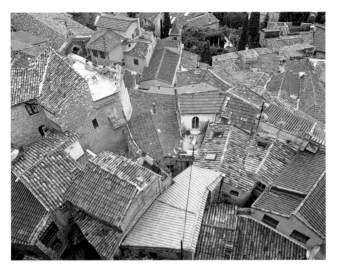

Bird's-eye view

High vantage points give you, quite literally, a whole new perspective on your subject. These French houses would not have been half as photogenic if shot from ground level. By getting a bird's-eye view, though, the photographer has created a stunning, almost abstract image, full of interesting textures and shapes.

Find the best viewpoint

This popular tourist site in New Orleans, USA, clearly offered plenty of potential. But before actually taking any pictures the photographer spent half an hour wandering around to find the best vantage points. By varying the lens used and the vantage point from which the shot was taken, it was possible to produce a wide variety of images with little wastage.

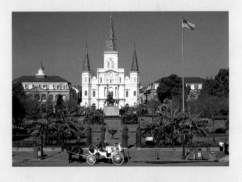

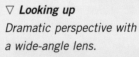

▽ **Looking up**
Dramatic perspective with a wide-angle lens.

△ **Distant view**
You can get an overall view from a greater distance.

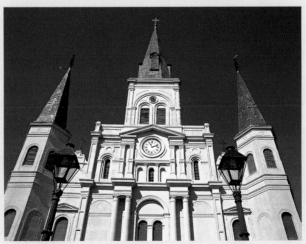

△ **Foreground interest**
Foreground interest helps give the picture a sense of depth.

Focal Length

The amount of the scene which a lens takes in is described in terms of its focal length. A standard lens captures about as much as the human eye. A wide-angle lens takes in considerably more, while a telephoto lens acts like a telescope and brings distant subjects closer. Some cameras feature just one focal length of lens, normally slightly wide-angle, though most compact/digital cameras now feature some kind of zoom. With a single lens reflex (SLR) camera, you can change between a wide range of lenses.

Switching lenses or altering the zoom is one of the easiest yet most powerful ways of determining the overall look of the picture. Try not to get in the habit of using just one focal length – aim for lots of variety in your picture-taking.

◁ **Telephoto details**
With a telephoto lens, or the tele setting on a zoom, you can choose to fill the frame with details at a distance or isolate subjects that are close at hand.

▽ **Wide-angle for dramatic perspective**
A wide-angle lens or setting (35mm or less) does more than simply let you get more into the picture. It also creates a much more dramatic perspective.

Accurate framing with a zoom lens

Most modern cameras, both conventional and digital, feature a zoom lens – and this can be very useful for exact framing. At a wide-angle or standard focal length, you can take general scene-setting images. And by zooming in to a telephoto focal length, you can focus on just part of the subject. Don't get too lazy, though – you still need to walk around to find the best viewpoint.

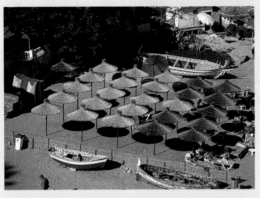

▷ **Standard setting**
At its standard setting, this zoom lens captures a general view. The photo has a fairly uninspiring composition.

△ **Zooming in**
Pushing the lens out to its longest setting makes it possible to focus attention on just part of the subject – with the feel of the shot changing completely.

Don't leave it till later!

Using a wide-angle may give you lots of options for re-composing when your shots are on the computer. But take note: the quality is better if you frame accurately when you shoot, rather than magnifying part of the subject later.

△ **Portrait lens**
Short telephoto lenses (80–35mm) are known as 'portrait' lenses, because of the flattering perspective they give to pictures of people.

▷ **Standard lens**
Standard lens (35–50mm) settings are great for general picture-taking situations and ideal for many everyday subjects.

Creating a
Feeling of Depth

The problem with pictures is they're two-dimensional — and the world itself is, of course, 3D. But you can prevent your images looking flat by manipulating the depth of field — a zone of acceptable sharpness in the finished picture. This is determined by the aperture and the length of the lens.

▽ **Differential focus**

Having part of the picture sharp and part out of focus, known as differential focus, can be an effective way of concentrating attention on just part of the subject.

Small aperture and wide-angle lenses give lots of depth of field, with most of the subject sharp. In contrast, using large apertures and a tele lens will limit depth of field and give a smaller zone of sharpness.

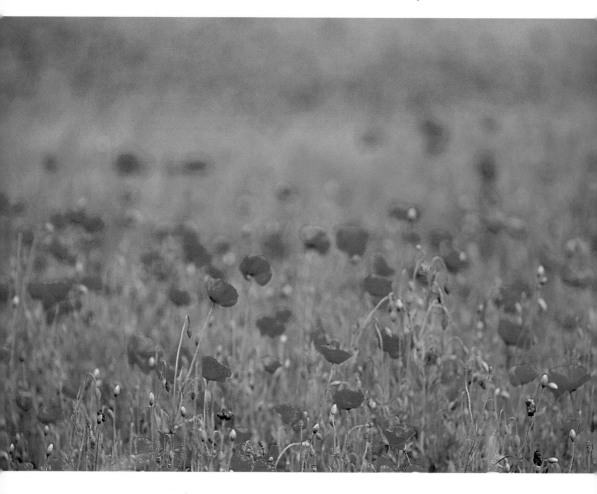

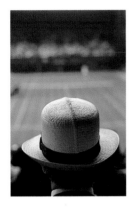

△ **Large aperture**
You can limit the amount of the scene that appears in focus by setting a large aperture, such as f/4 or f/5.6. This makes the main subject stand out clearly from the background.

△ **Small aperture**
By setting a small aperture of f/11 or f/16, you can keep everything in focus from the front to the back.

◁ **Foreground interest**
Relating something in the foreground to something in the background is a great way of establishing a sense of depth.

△ **Wide-angle sweep**
Those who have an extreme wide-angle lens can easily create images that have a dramatic sweep from front to back.

People in Focus

We all take pictures of people — family, work colleagues, friends, people we see in the street. Sometimes we even turn the camera on ourselves! And every occasion provides the opportunity to produce something more than a mere 'snapshot', something that seems to capture the essence of your subject's character.

One of the key things to consider is whether you want the person to pose for the shot, or whether a 'candid' would be better so that your subjects are unaware of you and your camera.

Posed shots have the advantage of giving you more control over the look of the picture, but with the disadvantage that some people 'freeze', resulting in fixed expressions or cheesy grins. Candids may not be as good technically, but generally the expressions are more natural. The approach you use will depend upon the subject and situation.

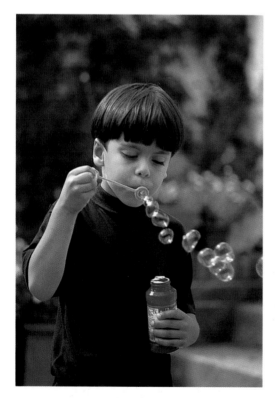

△ **Candid camera**
Allowing children to get lost in what they're doing results in more natural photographs.

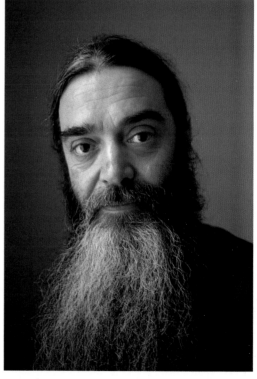

△ **Character study**
Some people have a wonderfully characterful face, and a simple approach is the best.

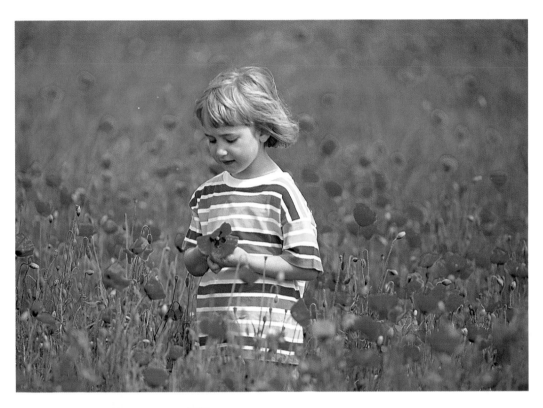

△ **Posed but candid**
It is possible to combine the posed and candid approaches with some success. Having asked the young girl to pick some poppies in this field, the photographer left her for a moment to become absorbed in what she was doing. The result is a natural-looking image.

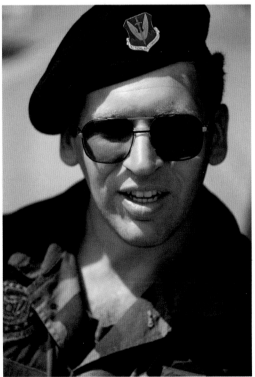

△ **People at work**
People at work, dressed in the appropriate clothes, can make portraits more interesting.

Get better portraits

- use soft light, not harsh sun

- take lots of different pictures

- give children something to do

- get couples/groups to interact

- watch carefully to capture the best expression

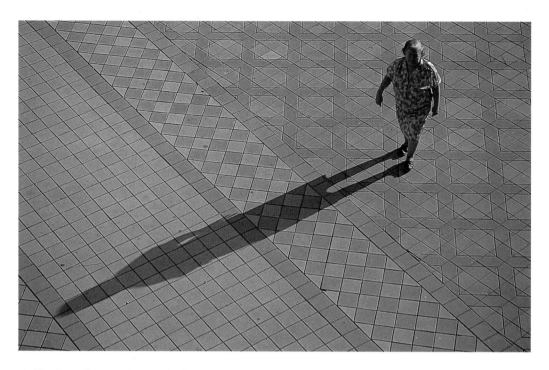

△ **The long view**
Pulling back and
showing people in
context often works.

▽ **Go in close**
Tight cropping to fill
the frame is a good
way of gaining impact.

▽ **Capture the moment**
Have your camera
ready to take the
unexpected expression.

▷ **Isolate your subject**
Isolate your subject
with a telephoto lens
and a large aperture.

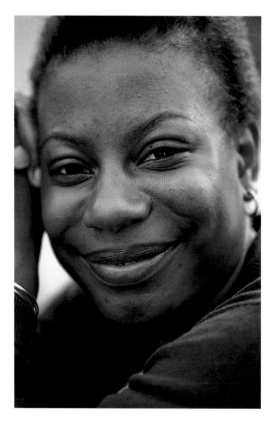

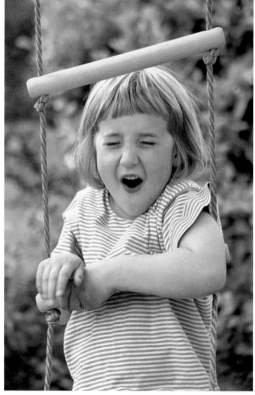

Textures and
Patterns

▶▶▶ ▶▶▶▶ Most of the time as photographers we think about subjects – for instance, action, portraits, landscapes, children, travel and still-life. But there is another way of approaching picture-taking, which involves thinking beyond the subject and considering instead what it looks like in terms of textures and patterns. If you've never tried it before, you'll find that coming at photography in such a way will open up brand-new vistas.

Subjects which you've walked by in the past without even a second thought will suddenly seem full of potential.

Often, it's simply a matter of noticing how isolating just part of the subject makes it more interesting and reveals aspects of it which are not normally apparent.

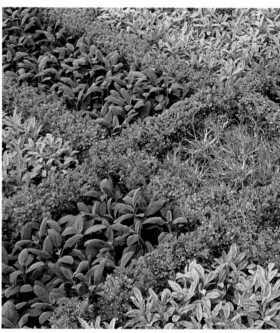

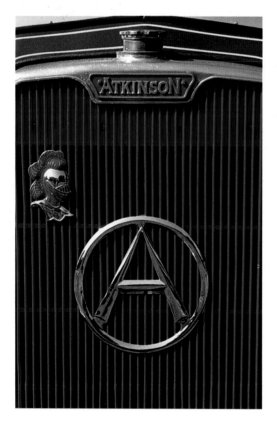

◁ **Vintage vehicle**
Using the telephoto lens makes it easy to emphasize what is interesting about a subject. Here, the radiator grill of a vintage vehicle, with its round logo and straight lines, makes a strong composition.

△ **Garden pattern**
Patterns add structure to pictures – as here, where the 'cross' hidden in the greenery becomes apparent only once you have cropped in on it.

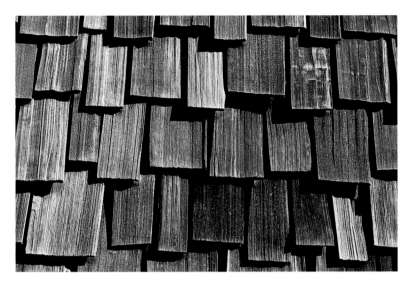

◁ **Wooden roof**
Houses can provide
wonderful raw material
for texture and pattern
shots – especially
when they're built in a
traditional way with
bricks, wood or stone.

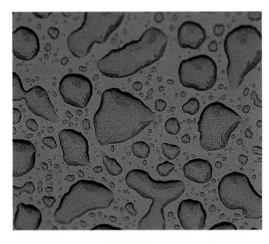

◁ **Water droplets**
The battered old car
on which these water
droplets were lying
was not in itself
photogenic but, by
cropping in close, the
photographer has
created a pleasing
composition.

▷ **Raking light**
The low, directional,
warm light of autumn,
sometimes known as
'raking' light, is
perfect for bringing
even the most
mundane subjects to
life – as here, where
the texture of a few
leaves is revealed.

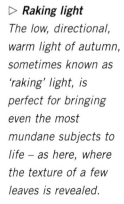

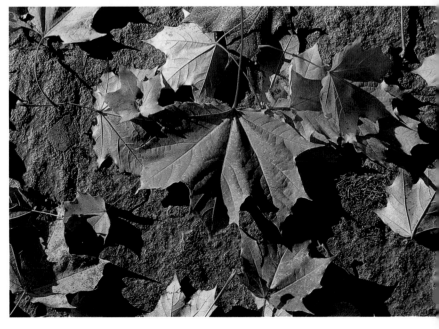

A Sense of Place

One of the most popular uses for photography is to capture memories of the places we visit – whether it be a day trip, a weekend away or a full-blown holiday. But so often such pictures disappoint. Too many shots simply show the family in front of the hotel or on the beach, while the sense and spirit of the location is lost.

▽ **Perfect settings**
While there's a lot to be said for cropping in tight for impact, there's also a strong case in travel work for showing the subject in its wider setting.

With a little care, though, and some preparation, it's possible to produce shots that will be the envy of your family and friends. What is it about the place that makes it special? What gives it a unique character? The answers to such questions can help you choose what to photograph and how to photograph it. If you're using a digital camera, take lots of shots and edit them at the end of each day. If you're using film, then plan more carefully – but try not to skimp on film – it's relatively cheap!

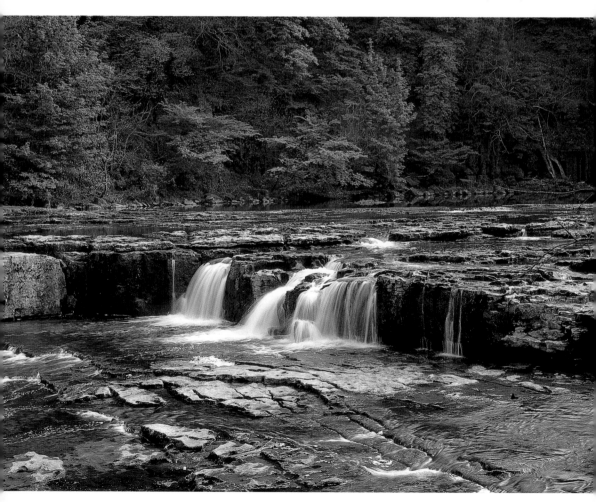

◁ **The ideal view**
Whenever possible,
take time out to flip
through a guide book
before arriving at an
area you don't know.
In the case of the
white village of Olvera,
Andalucia, in Spain,
the photographer was
well aware that the
perfect shot was to
be gained by going
to the top of the town
and looking down.

▽ **Local colour**
As well as the getting
the 'big picture' on
film, make sure you
also capture some of
the many details that
give a place its own
individual character.

▷ **Say it with people**
Where else but
Mississippi? One of
the easiest ways of
evoking a sense of
place is taking
pictures of the people
who live there.

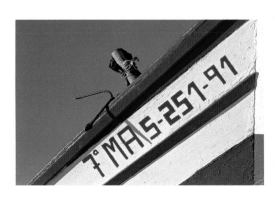

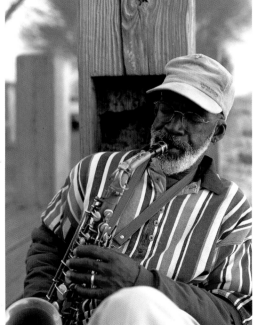

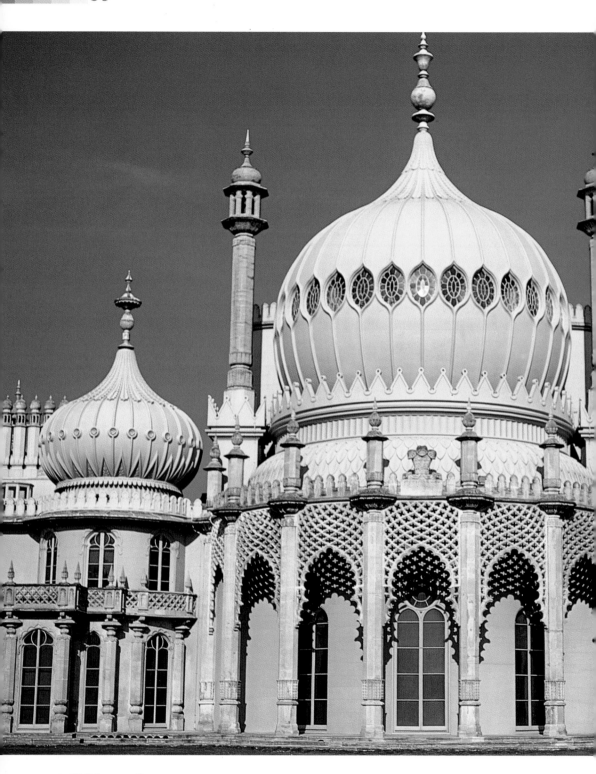

△ **Well-known sites**

Some famous structures seem to symbolize the cities in which they are located. Paris has the Eiffel Tower, Berlin has the Brandenburg Gate, and Brighton has its Pavilion (above).

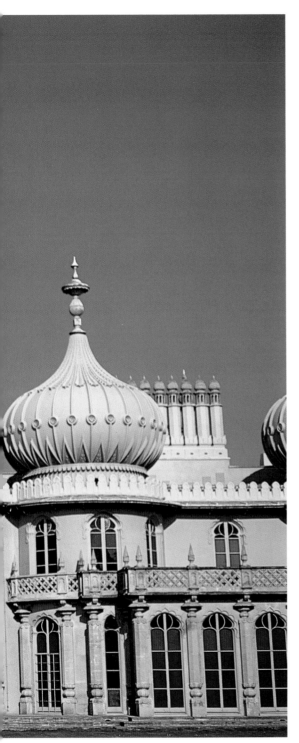

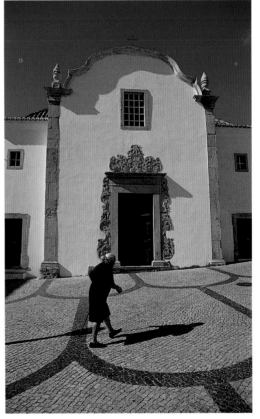

 ▷△ **Las Vegas**
Signs can be a great
way of capturing the
spirit of a place. This
is clearly Las Vegas.

▷ **Portuguese scene**
By bringing people
and places together,
you can tell a story
most economically.

Flash Photography

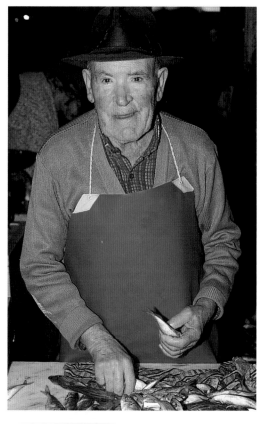

▶▶▶ Many photographers shy away from using flash, because it's more difficult to anticipate how the shot will actually look, and because the results often disappoint – they're too dark or too light, or people have glowing red eyes.

But modern cameras, both conventional and digital, feature advanced flash systems that take the guesswork out of flash photography, making it easier to produce first-class images when there's not enough light.

As a general rule, however, you should only use flash when it's absolutely essential. Daylight tends to be much more attractive and subtle than the blast of frontal light you get from a built-in flashgun.

▷ **Straight flash**
In situations like this, inside a darkened market, you don't have much choice – use flash on the camera or miss the shot.

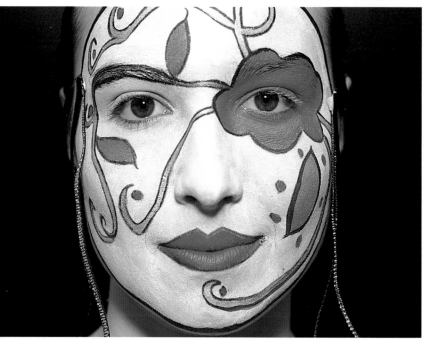

◁ **Flash for impact**
Direct flash gives you well-lit pictures and a 'catchlight' in the eye – making it ideal for subjects where the overall impact is more important than any subtlety.

Fill-in flash technique

If you only think about taking flash pictures when light levels are simply too low, think again. One of the most useful photographic techniques is fill-in flash, where the flashgun emits a low-powered burst of light designed to supplement but not replace the existing illumination. Try using this technique to give a little extra punch to your shots on dull days and to reveal detail in dark shadows in contrasty lighting conditions. Not all cameras or flashguns have a fill-in flash facility, but if yours does it's worth taking advantage of it. Increasingly, fill-in flash is automatically provided as required by the situation on compact and digital cameras, but on some models you have the option of manipulating the flash output yourself. As these pictures show, the difference you get can play an important part in the success of your shots.

△ *Correct fill-in flash balance*
The illumination from the flash balances perfectly with the existing light to produce a natural-looking result.

△ *Flash overexposed*
The illumination from the flash is too much, overpowering the existing light and giving an unnatural-looking result.

△ *Flash underexposed*
The illumination from the flashgun has been insufficient to make much impact, and the subject remains too dark.

Close-ups

One of the great things about digital cameras is their close-focusing abilities. Many allow you to get just a few centimetres away from your subject for shots that are really dramatic. And with an electronic viewfinder, you can see exactly what the finished picture will look like.

But even if you're shooting with traditional equipment, there are plenty of opportunities to close in on your subject – close-up filters are reasonably priced and give decent results. And in the computer, you can easily enlarge part of the image to create a dramatic close-up.

▷ **3-D flower**
Getting in close to tightly frame this dahlia throws the background completely out of focus for a wonderful three-dimensional effect.

▷ **Table-top study**
Everyday objects can make wonderful close-up studies. Look around at what you have in your kitchen, office, garage or garden shed, you'll realize that you need never be short of subject matter. Sheets of coloured card can be acquired at modest cost from art and stationery shops.

▷ **Butterfly**
Butterflies are popular subjects, and more accessible than many photographers think. The secret lies in approaching them slowly – avoiding any sudden movements that could scare them away. If you have a zoom lens, using it at its extreme telephoto setting will help you keep your distance.

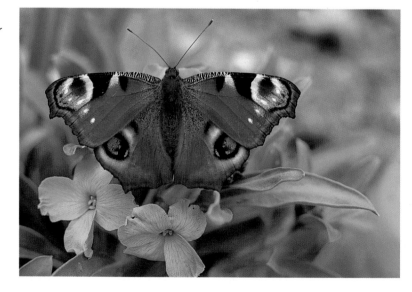

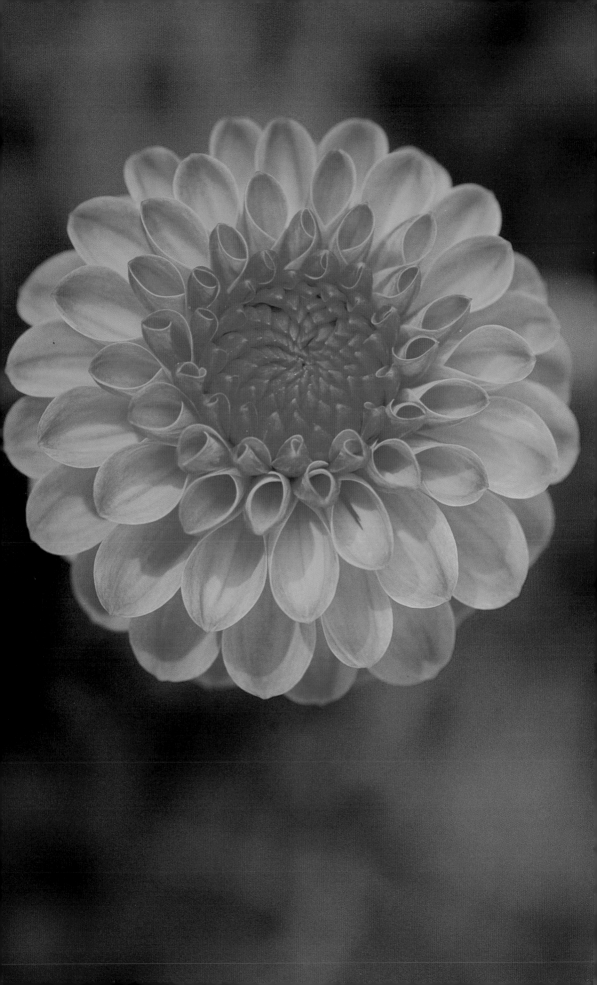

Night and **Low-Light** Photography

Thanks to the availability of fast film and sensitive digital cameras, it's now possible to take pictures in all kinds of weather and at virtually any time of the day or night. If you're looking for moody, atmospheric shots, one of the best times to go hunting for images is when light levels are low – in short, at night.

In practice, though, the best pictures are taken just before it gets dark, either when there is a warm glow or still some blue in the sky.

However, because there's not much light around, shutter speeds will be low – so you'll need to support the camera on a tripod or in some other way to avoid camera shake.

Tips for success

- support the camera firmly

- get up early in the morning

- look out for floodlit buildings

▽ **Sunset spectacular**
Sunsets are among the most photographed subjects in the world – not surprisingly, because the results can be extraordinarily beautiful.

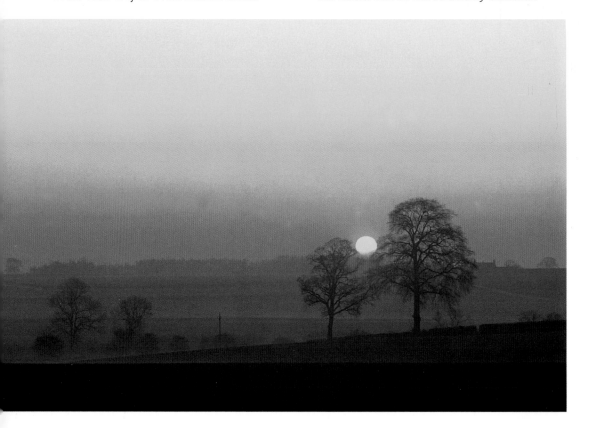

▷ **Twilight silhouette**
Twilight, just after the sun has gone down but before it grows dark, can produce some of the most sumptuous colours. However, the secret of success lies in finding a suitable subject – as here, where the warm tones of the afterglow reflect from a lake to give a wonderfully evocative silhouette.

▽ **Neon signs**
Neon signs almost always make good pictures – such as this shot of the fantastic lights in Las Vegas, USA.

▷ **Early riser**
The quality of light you get early in the morning is different from that late at night – and sometimes every bit as atmospheric.

▽ **Floodlit building**
The best time to shoot floodlit buildings is about an hour before it gets totally dark. That way you get a much more balanced exposure, with detail in both the building and the surrounding area.

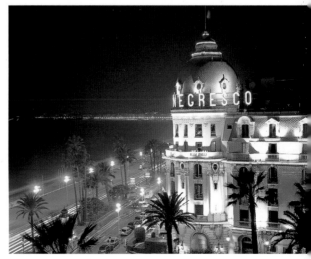

Capturing
Movement

One of the most interesting challenges in photography is capturing movement. Whether it be a Formula One car hurtling round the track at 200 miles per hour, or a toddler taking his first tentative steps down the path, action will test your skills to the limit. Having a camera with autofocus and the option to select the shutter speed will help. But at the end of the day, it's all about having sharp wits and good timing.

Remember also, it's possible to start with a sharp subject and add controlled blur in the computer (see p. 114).

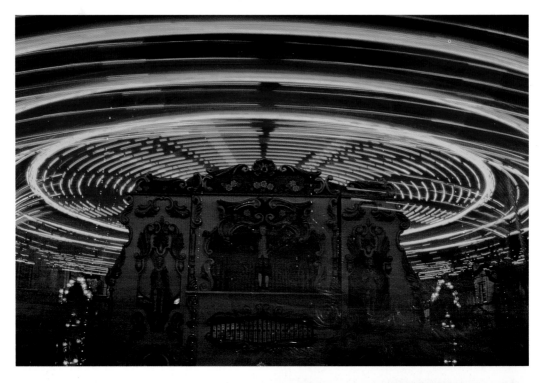

△ **Fairground ride**
Captured at a shutter speed of ⅛ sec, the lights of a fairground ride seem to be whirling round at high speed, increasing the sense of excitement and speed.

▷ **Waves washing over pebbles**
You don't need to go to sports events to capture action, it's everywhere around you – even down by the seaside, with waves washing in over pebbles.

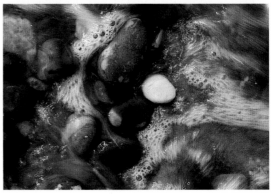

To freeze or blur? That is the question

Where there is movement you have a choice: to freeze it with a fast shutter speed, or to blur it with a slow one. Most of the time you'll probably choose to freeze, because you can see the subject more clearly. But with the subject ending up static, all sense of movement is sometimes lost, which is why it's a good idea to experiment with longer speeds.

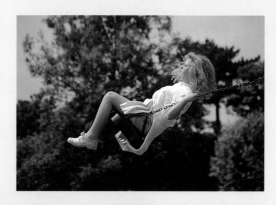

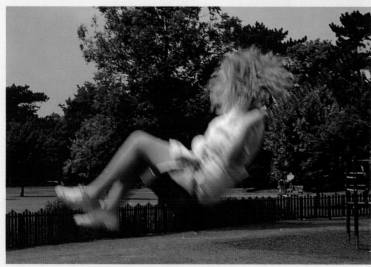

△ **¹⁄₅₀₀ second**
A fast shutter speed freezes the movement of the girl completely.

◁ **¹⁄₃₀ second**
Such is the speed of movement that even at ¹⁄₃₀sec the girl and the swing have blurred considerably.

Moving pictures

If you're using a conventional camera that doesn't give you direct control over the shutter speed, you can influence it by your choice of film speed. With a fast film (ISO 400 or above), the camera is likely to set a fast shutter speed. With a slow film (ISO 100 or less), it will normally set a slow shutter speed.

▷ **Roller coaster**
Roller coasters call for fast shutter speeds – and if you're shooting on a bright, sunny day, that should prove no problem. The key thing with a subject like this is timing – anticipating the peak of the action, and firing the shutter just before it to allow for the delay in the picture being taken.

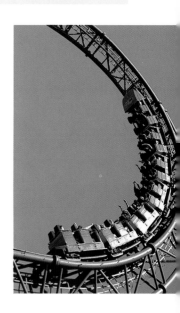

Better Buildings

▶▶▶ ▶ ▶▶▶▶ Buildings are one of the most accessible subjects for photography. Unless you live in a tent in the middle of the desert, the chances are that you are surrounded by lots of different types of buildings – old and new, for dwelling or business, and constructed from lots of different sorts of materials and in all manner of styles.

Capturing architectural subjects on film is also relatively straightforward. Often, you'll want to use a wide-angle lens to get everything in, especially in cramped locations – although working from a distance with a standard or telephoto lens can avoid the problem of buildings looking as if they're falling backwards when you have to tip the camera back to get the top in.

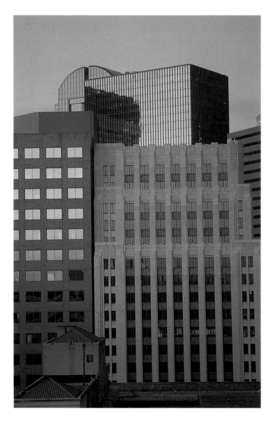

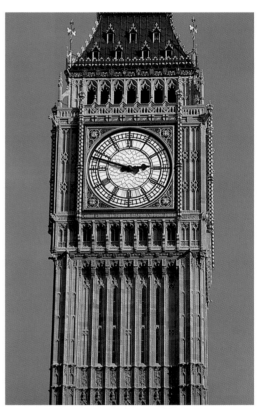

△ **The warmth of the evening sun**
Modern skyscrapers can look very attractive if you photograph them in the right light. Here, the warmth of the evening sun gives them a golden glow. This effect can be enhanced later by manipulation in the computer.

△ **Big Ben, London**
When the subject is tall rather than wide, make sure you tip the camera on its side to get as much in as possible. For this shot of Big Ben, the photographer used a telephoto lens to concentrate attention on the clock face.

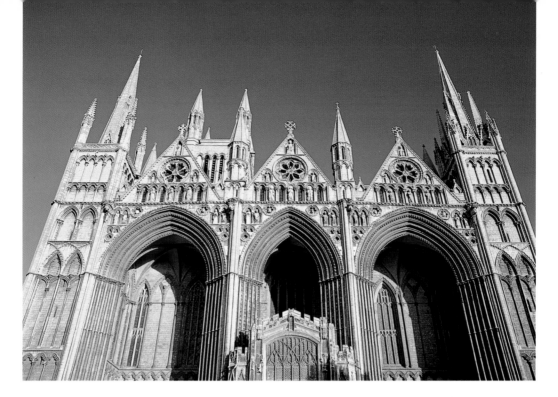

△ Traditional studies
Cathedrals are among the most photogenic architectural subjects. As a rule, wide-angle lenses are best, allowing you to get as much in as possible and show off the size and splendour of the building. But also try capturing a gargoyle or two with a telephoto.

▷ Going abstract
Modern buildings are ideal for creating interesting abstract compositions. By using a telephoto setting, you can isolate parts of the structure which show appealing shape and form. Think about pattern-creating rather than being 'faithful' to the building.

Building success

Try photographing a building in a logical sequence:

• start with a wide-angle lens, walk around the building and get the best overall shots

• switch to a telephoto lens and isolate eye-catching details

△ Filling the frame
Don't feel you have to include all of the building in the picture. Cropping in tight to fill the frame by using the top end of your zoom can sometimes give a more pleasing effect.

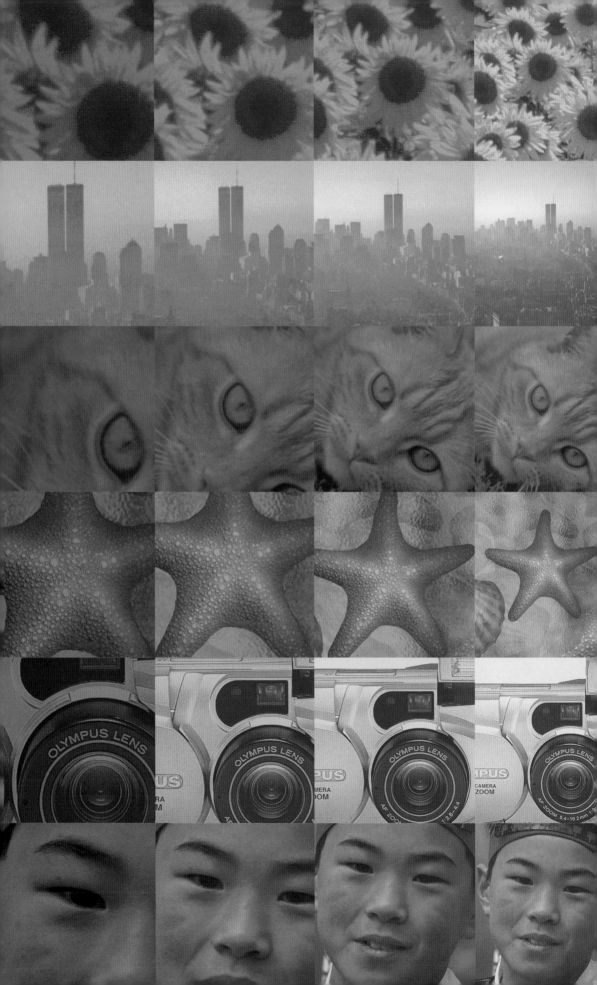

3

▶▶▶▶

Enhancing the
Image

Manipulation
Software

Whether you've gone for a digital camera or a scanner as your input device, the first thing you will want to do is connect it to the computer – and you'll usually find a complete set of cables included for most modern machines. You'll also get a 'bundle' of software which will enable you to use the equipment, and it may also offer additional features such as image retouching and manipulation.

Installing the software is normally a relatively straightforward process, but here is some advice to make it as painless as possible. You will then be ready to start taking pictures with the camera or doing your first scan, but first there are a few things you should do to set your system up so it works to the optimum.

Calibrating up the monitor

Setting up the computer monitor so it gives an adequate sense of what images will look like once they've been printed is one of the more challenging aspects of digital imaging. Some of the advanced programmes allow you to calibrate the system, and you can even buy stand-alone packages – although these are more the domain of designers and graphic artists. Although it doesn't sound very scientific, the best approach is to continue making adjustments to the monitor and the printing on the basis of experience.

Allocating computer memory

No matter how basic or comprehensive your image manipulation software, you will only get the best from it if you give it plenty of working memory. As a rule of thumb, the software needs three to five times as much RAM (Random Access Memory) as the largest image you work with. If you regularly retouch and enhance 12 Mb images, a 36 Mb allocation of RAM is the minimum that's likely to be workable without the computer slowing to a snail's pace, and 60 Mb ideal. For 30 Mb images the range would be 90–150 Mb.

On a PC, memory requirements are changed under the 'Memory and image cache' settings of Preferences under the File menu. On an Apple Mac, you select the program and then choose 'Get info' from the File menu, which then displays a box where you can choose to vary the allocation.

Is my bundled software enough?

The bundled software is usually more than adequate to get you started, allowing you to get your images onto the computer and perform basic enhancement and manipulation. At the very least you should be able to correct brightness, contrast and colour – and often a whole lot more.

However, as the software provided is often a trimmed down or 'light' version of a well-known package, you may decide in time that you need the extra features and upgrade. You will also find there are specialist programmes available that allow you, for instance, to 'stitch' several images together to make a panorama, or distort images for creative effect.

△ **Digital camera software**
Most digital camera software displays all the images captured as thumbnails, and either downloads them all or just selected images.

△ **Scanner software**
The scanner interface can look intimidating at first, but you soon learn how it works.

Camera software

The primary purpose of the software you get with a digital camera is to download the images to the PC. Normally once you've connected them, selected the appropriate setting on the camera and started up the software, the camera and computer start 'talking' to each other, with small 'thumbnail' images of the pictures taken appearing relatively quickly on the computer monitor. At this point the camera is partly operated by the computer, and you can choose to delete certain images or download some or all of them. Once they've all been transferred, you can erase the card ready to take more pictures.

Scanning software

Scanners can sometimes be a little more complicated to set up than cameras, although often the procedure goes without a hitch. Certainly it will take a little while longer to get used to all the options offered by the software, as the interface can look initially like the flightdeck of an aircraft. The key thing to set is the resolution. If in doubt, go for 600 dpi on a flatbed scanner and the maximum resolution on a film scanner.

Generally you will get a 'preview' scan of the whole image from which you are able to select the part that you want scanned. So even at this stage you are beginning to make creative decisions about how you want the finished image to look. The tonal and colour calculations that are made automatically by the computer are normally accurate, but there will be an over-ride system if you feel that the settings need to be tweaked.

Tools for Digital-imaging

Having loaded your images into the computer and installed your software, you'll be itching to start playing with them as soon as possible – and really getting into the creative side of digital photography. But before you can do that, you've got to get to grips with what can seem at first a bewildering array of different image manipulation tools. Despite your eagerness, it's worth spending some time familiarizing yourself with what each one does, rather than diving straight in. You'll learn more thoroughly, and avoid wasting unnecessary time.

Using layers and blending

Using layers is one of the most fundamental techniques of digital enhancement and manipulation – yet many enthusiasts avoid doing so because it seems to be complicated and difficult.

Layers are like transparent sheets of acetate laid over a photograph. Placing other images onto a new layer, or adding colouring or text, make it look as if the underlying image has been altered, when in fact, if you were to remove the layer, the original picture remains untouched. Working with layers, therefore, gives you enormous control over how parts of an image relate to each other – and this is particularly important when you start to montage several images together. In most software packages you can also exercise more control by means of 'blending modes' – which offer different procedures for merging the different layers.

◁ **A typical toolbar**
Most image-manipulation programs have a 'toolbar' where all the tools can be quickly and easily accessed. Even with the most basic packages you can copy, colour and correct all or individual parts of the image. Some of the icons also reveal other options when you click onto them.

Using the clone/rubber stamp tool

The rubber stamp tool is one of the most useful in digital imaging, as it allows you to 'clone' or copy one part of the image onto another. It is easier and more realistic when trying to remove an unwanted pylon in a landscape, to copy another part of the sky than try to paint it in.

Using the paintbrush, airbrush and pencil tools

These 'painting' tools all have similar properties, in that you can vary the colour, the size of the brush, and to a certain degree the pressure used. As a general rule it is better to reduce the 'opacity' of the colouring, so that it builds up steadily and more controllably.

Typical tools palette

Although different software packages have slightly different tools, some of which have slightly different names, in fact there's a remarkable degree of consistency in terms of the facilities and features offered. Most are also laid out in palette form like the one on the left, which is typical of what's available. In each case clicking on the tool makes it active.

 Marquee/crop Lets you select rectangular and elliptical areas

 Lasso Allows you to select any area of the image freehand

 Airbrush Sprays paint onto the image in a soft, controllable way

 Rubber stamp Lets you copy/clone parts of the image

 Eraser This is used to rub out any unwanted areas

 Blur/sharpen/smudge Allows you to blur or sharpen specific areas

 Pen Designed for the advanced user – you can mark out precise paths

 Measure A ruler, used for measuring the image

 Paint bucket Fills specified areas of the image with a chosen colour

 Hand A quick way of moving the image around the screen

 Move Useful tool that is used to move selected areas and layers

 Magic wand Selects pixels on the basis of similar colour

 Paintbrush Colouring tool, but with a softer edge than the pencil

 History brush Not available in every package, can 'undo' specified areas

 Pencil For hand drawing or colouring where a harder edge is required

 Dodge/burn/sponge Retouching tool that lightens or darkens areas

 Type Provision for adding text to your images

 Gradient Produces a smooth transition from one colour to another

 Eyedropper Lets you sample and replicate any colour from the image

 Zoom Enlarges the images so you can even retouch at the pixel level

Cropping and Changing Format

In an ideal world the pictures we take would be perfectly composed, but all too often we get something wrong at the picture-taking stage. Maybe we're so busy thinking about the subject that we don't notice an ugly or distracting background. Or perhaps the lack of a long telephoto lens prevents us going as close as we would like. In the days of traditional photography this meant ordering an expensive selective enlargement to see the picture at its best, but using digital imaging it couldn't be easier to improve things. Simply select the area you want and either trim/crop away the rest, or copy what you do want to a new file. It really is as simple as that! You can change a horizontal (or landscape) format image to a vertical (or portrait) one and vice versa – you can even create square or panoramic format photos.

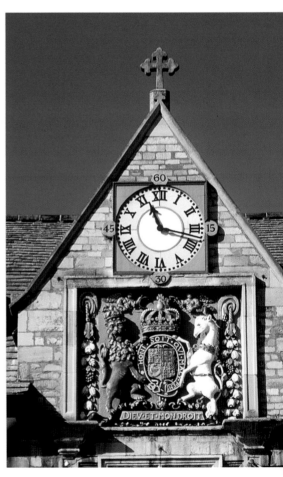

△ ▷ **Changing the format**

Taken in perfect conditions, the picture above is attractive but lacks impact. It was taken in the horizontal format rather than the vertical because the photographer did not have a powerful telephoto lens. However, using image manipulation software it takes only a couple of minutes to select the most interesting area and crop it to an upright format (right). Note how this greatly simplifies and improves the composition.

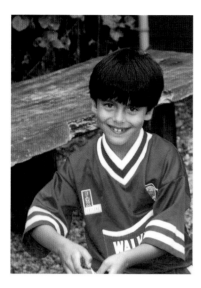

1 Distracting background
Although well caught, this shot is ruined by the drainpipe coming out of the head.▲

33.33% Doc 519M/519M

2 Selecting the area Simply indicate the area you want to keep, using the selection tool, then crop or trim the rest away. ▶

Which format?

While rules are made to be broken, as a guide use these formats for these subjects:

• vertical format is best for people and buildings

• horizontal format is best for groups and landscapes

3 Greatly improved Removing much of the distracting background, and especially the pipe, improves the composition enormously – and has the added benefit of filling the frame with the young boy for even greater impact.▶

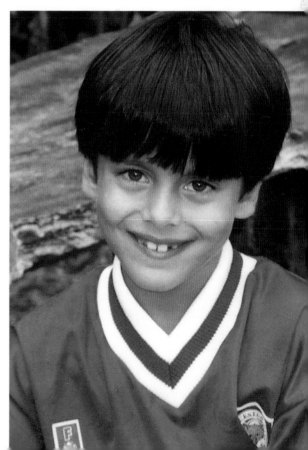

Brightness
and Contrast

All but the simplest cameras, whether they be digital or conventional, now feature a built-in exposure meter – and in the vast majority of situations they deliver perfect images. But no meter is 100 per cent reliable – in difficult lighting situations meters can get caught out. Happily, though, most resulting failures can now be rescued. The quickest and easiest way to do this is to leave it to your image-manipulation program, which will have some kind of 'auto levels' feature. With one click the contrast and brightness are optimized – and in most cases that's all you need to do. Many programmes also feature separate 'brightness' and 'contrast' controls, which allow you to adjust each independently. More advanced and adventurous users will also want to check out the 'levels' and 'curves' options.

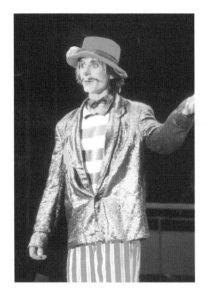

△ ▷ **Overexposure**
Even the most advanced meter can be misled by a dark background into overexposure – as in this clown picture (above). But unless the problem is too extreme, you should be able to salvage the image by juggling with the brightness and contrast levels (right).

1 ***Underexposure*** *As a result of the white wall behind this girl, the image was underexposed, with grey, muddy tones. It is also rather flat, due to the lack of directional lighting. In traditional picture-taking terms it would have been classed a failure, but with digital imaging it can easily be salvaged.* ▶

2 ***Using 'auto levels'*** *While you can adjust the brightness and the contrast independently, clicking on 'auto levels' usually gives a near-perfect result automatically – and in seconds. Sometimes 'auto levels' doesn't work and manual adjustment is required.* ◀

3 ***Finishing touch*** *There are times when you'll want to tweak what the automatic setting gives you. Here, the image has been lightened a little more to help 'clean up' the skin tones for a more pleasing result.* ▶

Selective control

You can alter the contrast or brightness of just one part of the picture by selecting it with the 'lasso' tool and then using the correction tools in the normal way.

Colour Correction

Some pictures have poor colour balance – they're too warm (orange), too cool (blue), or display an unpleasant green colouring (fluorescent light indoors). You can fit a filter over the lens of a conventional camera to compensate, and some digital cameras have a 'white balance' control that makes adjustments automatically. However, all is not lost if your image has a colour bias because most image software has a 'colour balance' option.

Cyan, magenta, yellow and black – known as CMYK ('K' = black) – make up the overall colour balance of an image and can be modified using the 'colour balance' option to correct or enhance colour. This is based on the idea of 'complementary colours. Cyan is complementary to red, magenta to green, and yellow to blue. So if you want to remove blue you should add yellow, and if you want to increase magenta you should subtract green.

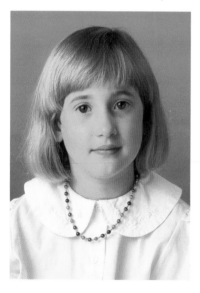

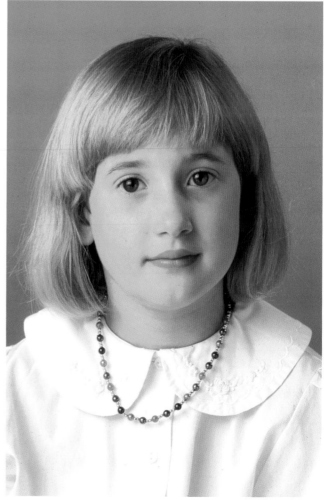

△ ▷ **Image too warm**
Sometimes there is an excess of yellow/orange in the lighting. This can be a problem when you take pictures under room lighting or late in the evening on a sunny day. The tone of this picture was made more neutral and more acceptable by adding blue and cyan using the 'colour balance' control – which has the effect of reducing the red/orange content.

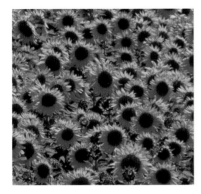

△ ▷ Creative colour
You can make colours more vivid or more subtle by altering the saturation. Generally this is done by means of a slider control, and you can preview the changes before saving them. The colours of these sunflowers have been boosted by combined use of the brightness, contrast and saturation options.

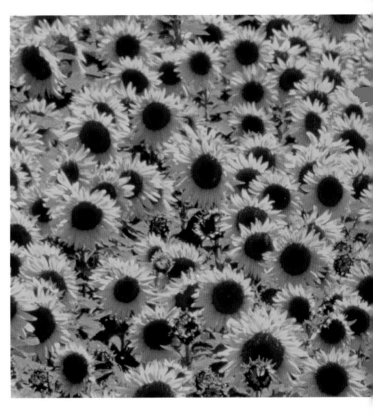

▷ ▽ Warming up cold light
Shots taken in overcast conditions or in shaded areas on a sunny day often have a blue bias. At the best of times this usually impairs the image quality, but with portraits it is a real problem as it makes people look distinctly unhealthy. However, simply removing some of the blue by adding orange results in a much more pleasing effect.

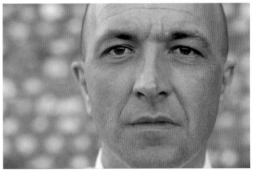

'Auto levels'

There's no 'quick fix' like 'auto levels' when it comes to adjusting colour – it really is a matter of experimenting with what are usually slider controls and finding out what works. In time, you'll have the experience to make corrections quickly and easily.

Improving
Sharpness

Images from scanners and digital cameras usually need to be 'sharpened' electronically before you print them out. In most cases, leaving it to the software's automated settings works just fine. You can also rescue images which are unsharp because of poor focusing or camera-shake.

1 *Original picture*
This image was scanned in from a 35mm transparency, and, as with all such scans, lacks a little of the crispness and sharpness of the original photograph.▶

2 *Unsharp masking*
The first stage in correcting a scan or digital camera image is to apply 'unsharp masking' – a subtle technique which gives a slightly enhanced image contrast.▼

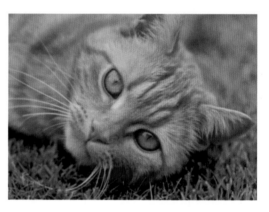

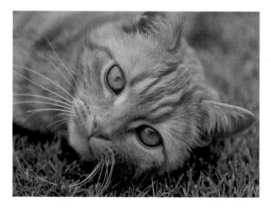

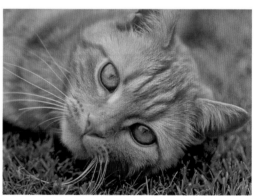

3 *Sharpening*
Use the 'sharpening' tool and the image appears to snap into focus on the screen – giving it much more bite. You can usually preview the effect before applying it to the picture.▲

4 *Too Sharp*
There's a limit to how much sharpening is acceptable. Use the 'sharpen' control excessively, and the contrast becomes too great and the picture looks as if something's gone wrong.◀




How sharpening works

When you use 'unsharp masking' or the 'sharpen' tool, the software searches for image edges and contours, and boosts the contrast in these areas – making the subject appear much sharper.

△ **Poor sharpness**
As well as being flat and uninspiring, this image is slightly unsharp – probably as a result of camera shake caused by shooting at too long a shutter speed for the conditions. However, using advanced digital imaging techniques the picture can now be salvaged.

▷ **Creative image**
By making a copy of the image on another layer and sharpening it using the 'sharpen' tool, and improving the brightness/contrast and colour using the appropriate tools, the image now looks sharp and interesting.

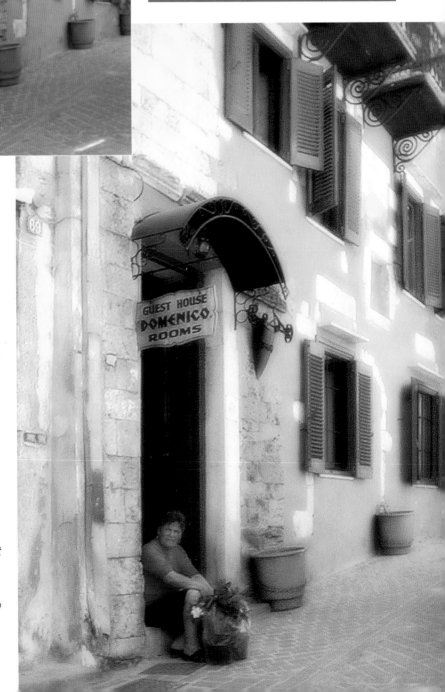

Correcting
Converging **Verticals**

▶▶▶ ▶ ▶▶▶▶▶ Buildings are a popular subject for photography, but they are not that easy to capture well unless you have specialist equipment.

One common problem is 'converging verticals', in which the building appears to be falling over backwards. This occurs when the camera itself is tipped over backwards – perhaps to include all of a large building in cramped surroundings.

Working conventionally, there was little you could do about the problem, but in digital photography it is relatively easy to rectify.

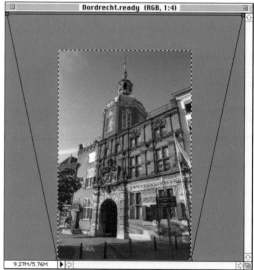

Dordrecht.ready (RGB, 1:4)

9.27M/5.76M

1 *Original image* *Captured with an ultra-wide-angle lens in extremely restricted conditions, this building looks looks as if it is falling over because the camera had to be tilted backwards to fit all of the building in.* ◀

2 *Enlarging the canvas The first stage is to make the canvas on which the image sits bigger – so that it can be stretched. Then select all of the image, and pull the top corners outwards using the 'handles' provided.* ▲

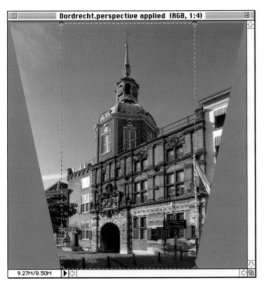

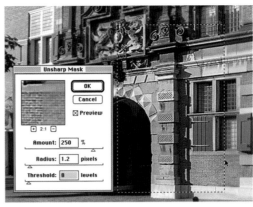

4 **Sharpening the image**
Once the correction has been completed, it's worth considering whether there are any other improvements that could be made. Here, the photograph would benefit from a certain amount of sharpening, so the filter 'unsharp mask' is applied. ▲

3 **Stretching the right amount**
Stretching the top of the picture the right amount is a matter of trial and error – just keep making adjustments until you can see that the uprights are how you want them to be. Then crop the image back to a rectangle.▲

5 **Copying across a burnt-out window**
One of the windows on the left-hand side has caught the sun and burnt out. This can easily be replaced by the one below. ▼

6 **Pasting window**
Selecting and copying the window below allows it to be pasted into the burnt-out window. Use the 'rubber stamp' tool to tidy up afterwards. ▼

7 **Finished image**
With the verticals corrected and upright, the image sharpened, and the window replaced, the photograph is now a considerable improvement on what it was like when we started to work on it. ▶

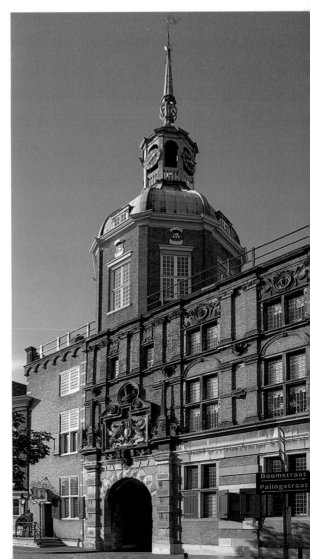

Removing Red-eye

Red-eye is a common problem when photographing people indoors with electronic flash. The sudden burst of flash can cause the eyes in the finished picture to glow bright red – creating a rather unflattering portrait! In the days before electronic imaging the photograph would be completely ruined, but now it's a relatively task easy to remove all the red colouring and create a natural-looking picture. Even if you don't feel you have any creative talent, you'll be surprised how straightforward it is. Of course, it's still better to avoid the problem in the first place, but if you do find it in your pictures it's no longer the end of the world.

What is red-eye?

Red-eye is caused by electronic flash reflecting from the blood vessels at the back of the eye. It is most likely to happen in low-light situations, when the pupils have opened up wide to let in as much light as possible, but can rear its ugly head any time that you use flash. Ways of minimizing the risk of red-eye include using your camera's red-eye reduction feature or turning on a room light to close down the pupils.

△ ▷ **Transformation**
Working steadily, you'll quickly become adept at taking out red-eye – or even changing the colour of someone's eyes completely for creative effect! Initially, you're bound to make some mistakes, but it won't be long before you're taking red-eye in your stride.

One-click options

Some popular image manipulation and enhancement packages have a handy 'one-click' red-eye reduction facility, usually with step-by-step guidance, that automates the process. Simply select the area to be corrected, click the button shown, and the red-eye disappears. What could be easier than that?

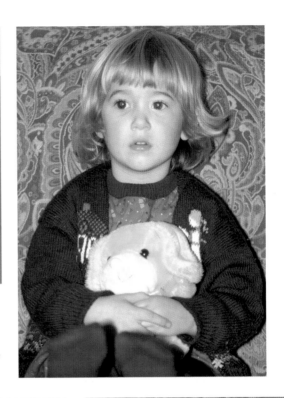

1 **Original shot** *This attractive shot has been 'ruined' by the ghoulish red-eye effect caused by the flash reflecting back from the eye sockets... or has it?* ▶

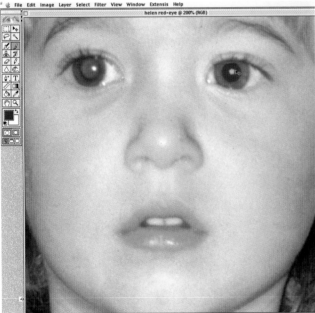

2 **Correcting the red-eye** *Manipulation software allows you to paint selected areas of the image. Enlarge the image on screen, select the new colour, here dark brown, and paint away.* ▲

3 **Final image** *In the original image, the red of the eye draws attention. Once that has been corrected, the result is a pleasing portrait that family and friends alike can enjoy.* ▶

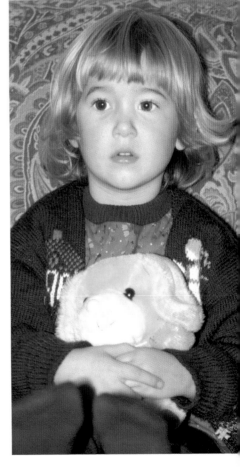

Colour into **Mono**

▶▶▶ ▶▶▶▶ Before digital photography came along you had to make an important decision every time you loaded a film – whether you wanted to shoot colour or black and white. If you wanted to do both, you needed to carry two cameras around with you, which was cumbersome and costly. These days, no matter whether you're using a digital or film-based camera, all you have to do is take the pictures in colour. Then, if you later think any would work better in mono, you can make a copy in seconds. What's more, once you have your black-and-white original, you can creatively alter it in your computer just as you could in a conventional darkroom – but without the need to black out a room and use messy and smelly chemicals.

△ ▷ ***Mono magic***
Having captured this portrait in colour, the photographer began to wonder whether it would work better in black and white. So he used a flatbed scanner to produce a digital image from the print and employed the 'save as' command to create a copy in monochrome.

▷ **Soft tonality**
Top left: Reducing
contrast using
'contrast' control
produces delicate
tones, but with no deep
blacks there's little
punch to the image.

▷ **'Correct' tonality**
Top right: A full range
of tones with a smooth
transition from black to
white suits the majority
of subjects.

▷ **Stronger blacks**
Bottom left: Boosting
the contrast gives the
image more impact –
though shadow detail
tends to get lost.

▷ **Contrast for impact**
Bottom right: If you
want a dramatic 'soot-
and-whitewash' effect,
try pushing the
'contrast' control much
further along.

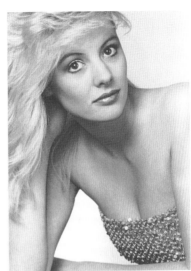

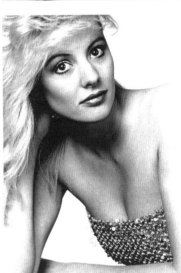

Why black and white?

Why bother to create to black-and-white images when the world itself is bursting with colour? Good question. But if you stop for a moment and think of the photographs that have moved you, chances are that many of them are mono. There's just something about the medium that delivers its message with more power and impact. Try it and see! Here are just some of its advantages:

- makes images more abstract
- focuses attention on subject
- gives a 'fine art' feel to the shot
- is a more expressive medium

Toning and Tinting

While no one can deny the appeal of a black-and-white image, you can sometimes take it to another level by toning – something that can be done much more easily and more accurately in the computer than in the darkroom. As you will immediately notice if you sift through your family's collection of photographs, by far the most popular colour for toning is sepia – so much so that we have now come to associate it with nostalgia. If you want to give a picture that 'olde-worlde' look, then sepia is the way to go. Many image programs include what is called a 'duotone' mode, which offers a relatively automated way of toning an image. If not, simply colourize it all over in whatever hue you fancy. But don't restrict yourself to sepia... blue, red, green, pink, orange – try them all and find out which works best.

△ *Original image*
While this black-and-white image works well, it has the potential to be more interesting – so why not tone it?

▽ ▷ *Sepia and blue*
Several alternative treatments were tried out across the colour range, with the sepia and blue working best – though the effect in each case is quite different.

▷ ▽ Creative sepia toning

There are various ways of changing the tonality of a black-and-white picture. For this shot of the car, the photographer drained the colour from a colour original (desaturation) and then changed the tonality using the hue control. The depth of colour could also have been altered using the brightness/lightness facility. All image software programs are slightly different, but all offer the potential for toning.

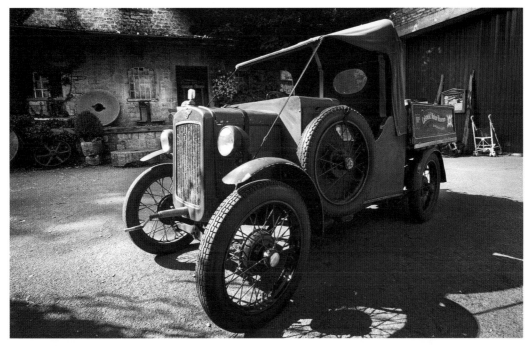

◁ ▷ Old photograph

While scanning this old photograph to give copies to relatives, the photographer decided also to make a version with traditional sepia colouring. This sepia version proved more popular, with most of the family preferring it to the original.

Dodging and
Burning

▶▶▶ ▶▶▶▶ Photographers printing their own work in a darkroom have long known the benefits of having complete control over the finished image. Two of their secret weapons, not widely known outside photographic circles, are techniques called 'dodging' and 'burning', which allow selected areas of the image to be lightened (dodging) and darkened (burning). In the darkroom these are specialist skills which take some time to develop, but in the computer you can master them in minutes. Simply select the appropriate tool, work on a copy of the image, and you'll soon get an idea of what is possible.

△ ▷ **Uneven lighting**
The original shot was lovely but rather spoiled by the dappled light falling on the nose. Using the 'burn' and 'rubber stamp' tools, it was an easy job to colour the light area in to match. With care, it would be possible to do the same with the large area of light across the jawline.

△ ▷ **Bringing up the eye**
Eyes often benefit from being brightened. With the 'dodge' tool, place a brush the same size as the eye over the area under the eyebrow, and little by little lighten it until the required effect is achieved.

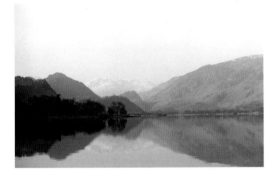

◁ ▽ **Burning in the sky**
Landscapes with pale, bland skies often look uninspiring, but they don't have to. You can use the 'burn' tool to darken a sky so that it looks entirely believable. The 'burn' tool was used repeatedly at low intensity along the top edge of this picture to give a subtle and graduated effect that would have been more difficult, although possible, using a paint tool such as the airbrush.

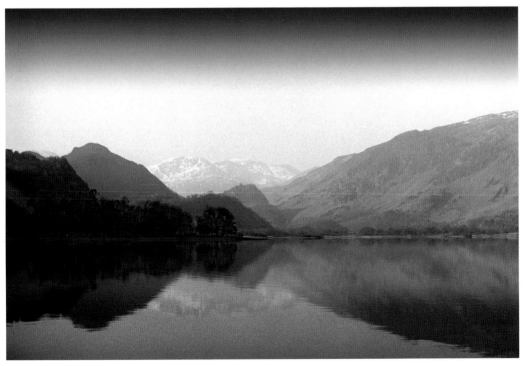

Changing Colour

A lot of the fun of digital imaging is being able to change things – and one of the easiest ways of making dramatic alterations is to mess around with the colours in a picture. Aware of how popular this pastime is, the manufacturers of manipulation software provide lots of ways of doing it. Some even offer a 'replace colour' option, which allows you to select any colour in the picture and replace it with one of your choice. Alternatively, you can paint over areas or use advanced masking techniques.

1 ***Original image***
With simple images like this, you can change colours in a variety of ways. Here, the starting point was to select the central 'N' – indicated by the 'marching ants' – using the 'magic wand' tool. ▶

2 ***Filling in the colour***
Having selected the area, you can then colour it in, using whichever tool you prefer. Because there was a large, undifferentiated area of colour, the 'paint bucket' tool was used for this picture – but most other painting tools would have been equally viable. ▶

3 ***Continuing the changes***
Having completed the change of the 'N' to green, the background was then selected and painted yellow and the blue border then selected and replaced with a red one. The whole process took no more than ten minutes from start to finish. ▶

1 **Original image** *For more advanced colour control, you'll need to work using the 'layer' facility (see p. 72). You can start with a colour image or, as here, the original can be in black and white.* ▲

2 **'Feathering' the image** *Cut out the image. Then select the cut-out area and use the 'feather' option to soften the pixels at the edges of the image. It is important to feather the edges so that the cut-out area will blend in with a new background.* ▲

3 **Cut out and colour** *Having cut the car out with the 'lasso' tool, make a 'mask' in the same shape as the car on a separate layer and fill it with colour.* ▲

4 **Blending the colour** *Use the 'blending' control to vary how the colours blend between the different layers. The car can then placed on a background of your choice.* ▲

5 **More options** *Once the layers structure is in place, it is a straightforward job to change the colour again.* ▲

6 **Be imaginative** *Once you have mastered the technique you can even add designs to the image – such as the British flag used here.* ▲

Distortion and
Stretching

One of the great joys of digital photography is that you no longer have to record things just as they were. You can leave reality behind and create more interesting visions of the world. Nowhere is this more true than when it comes to distorting and stretching images.

▽ *Sweet portrait*
If you're looking to distort a portrait, the more attractive it is to start with the more powerful the effect seems to be.

As we have seen, these techniques can be used to rectify 'faults' such as converging verticals (see pp. 82–83), giving a more 'correct' result. Theycan also be employed to give pictures added impact. So a landscape or architectural shot can be stretched to help open up the perspective, or squashed for a more concentrated composition.

The easiest way to get started is by using some of the 'auto' effects available on most programs, and then progress to working manually.

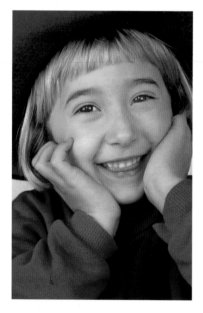

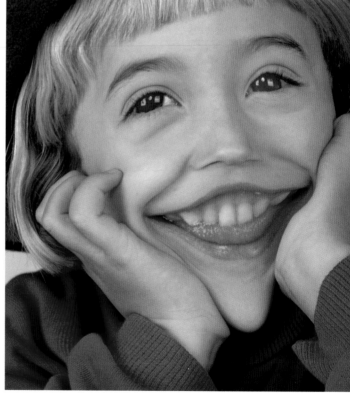

▷ *Rubber features*
Using a special 'goo' package, it is possible to stretch the features as if they were rubber, exaggerating as with a caricature.

▷ **Original picture**
Pictures with bright colours
and clean, graphic shapes where
the subject is clearly defined
respond best to stretching and
distortion.Such effects can be
created in seconds in most
software programs.

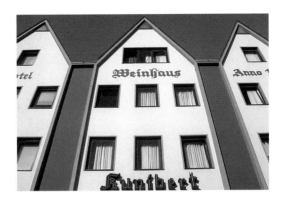

◁ **Ripple effect**
This neat 'ripple' effect makes the image look
as if it were photographed as a reflection in a
pond or river, with slight ripple effects across
the surface.

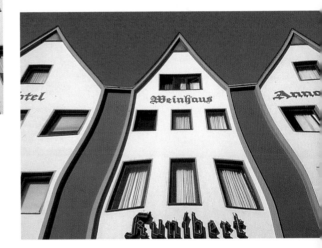

▷ **Squashed**
Squashing in the middle part of the image
gives an interesting, dreamy effect. The
greater the degree of squash, the more you
leave reality behind.

◁ ▷ **Spherical effect**
Some manipulation
programs allow you to
mimic the effect of a
fish-eye lens, which
produces a spherical
image, with the central
part of the scene
looking as if it is close
to the viewer while the
edges appear to be
much farther away.

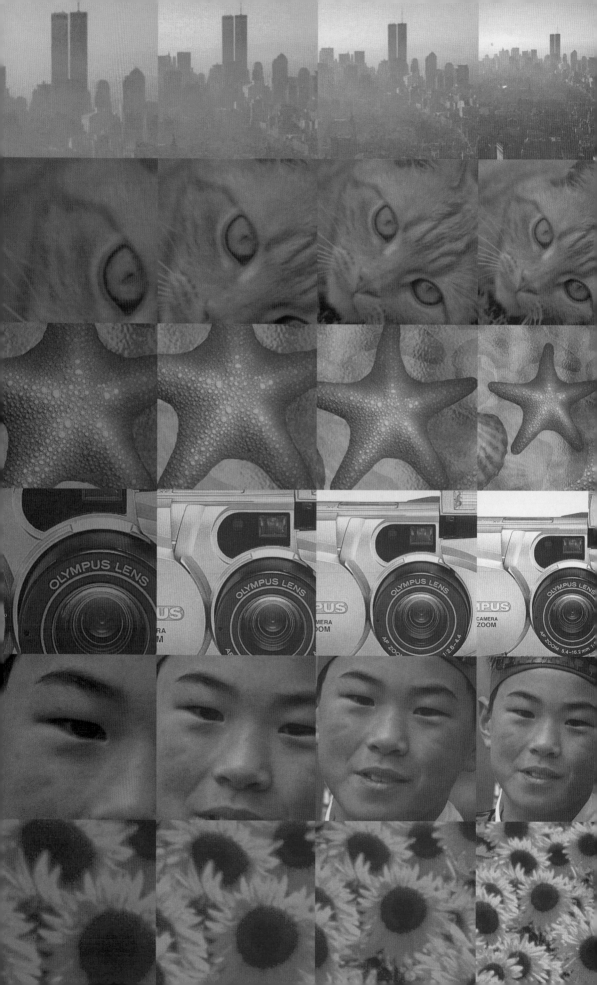

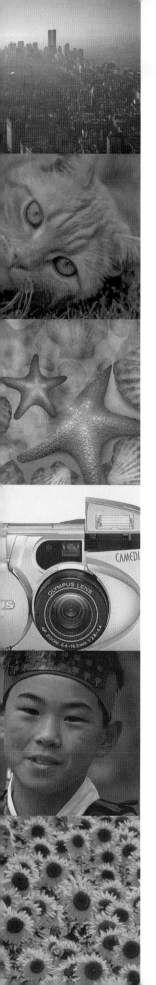

4

Creative
▼ Imaging

Classic **Photo**
Effects

Until recently, certain photographic effects, such as solarization, lith and bas-relief, were the exclusive domain of those with advanced darkroom skills – but digital imaging has changed all that.

Now such classic techniques are open to anyone with a computer – and you don't need smelly chemicals or a blacked-out room. All you need is an ordinary image to start with and an image-manipulation program offering these options – which most of the popular ones do.

△ **Original picture**
The original picture is a pleasing likeness, but in digital imaging it's only the beginning – there are many different ways it can be enhanced.

▷ **Lith – pure black and white**
Lithographic film and printing – lith for short – reduces monochrome images to pure black and white. This is easier to do in the computer than in the darkroom, with the added advantage that you can control exactly what will be black and what will be white.

△ **Reticulation – visible grain**
In conventional silver-halide
photography, the grain-like effect of
reticulation is caused by processing
a film incorrectly, but the result can
be highly attractive. The effect can
be emulated in the computer.

△ **Bas-relief – embossed effect**
The metallic embossed effect called
bas-relief, in which the image
seems to stand out 3-dimensionally,
is not easy to create and control in
conventional photography, but done
digitally it's a breeze.

▷ **Solarization – reversed tones**
This dramatic technique is hard to
control and difficult to repeat in
the darkroom. In the computer,
however, when you can simply dial
in the same settings and get the
same result time after time.

'One-click' control

Producing most of these effects is
easy – select the 'filter' you want and
follow the suggested settings. As you
become more experienced you can
fine-tune them yourself.

Filter Effects

▶▶▶ In the same way that you can place dozens of different filters over the lens to create interesting effects, so you can call up a whole host of digital 'filter' effects in most image-manipulation packages. Some are subtle, others more dramatic, but whatever your preference there is bound to be something to suit the subject in hand. The effects shown here are just a small sample of what's available – so you'll never get bored. And in each case, you have full control over how strong the effect is.

▷ **Original picture**
A bright, colourful subject with sharp outlines – like this image of crocuses – lends itself to a variety of filter effects.

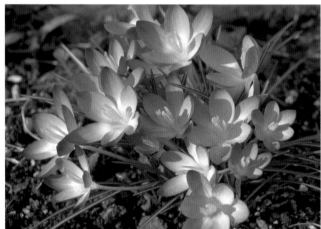

△ **'Mosaic' filter**
*By changing the image into large pixels, the 'mosaic' filter makes the image more abstract while remaining recognizable. **Inset:** The cell size of the pixels can be controlled.*

△ **'Watercolour' filter**
This classic filter gives fabulous results with the right subject, especially natural-history shots and portraits. Don't be too heavy-handed with this filter – go for a light, airy feel.

△ **'Spatter' filter**
This filter gives an attractive, smooth-textured effect as if the image has been air-brushed on to a piece of paper. **Inset:** The stronger the settings, the greater the effect.

△ **'Twirl' filter**
This effect is rather gimmicky and may not be to everyone's taste – but for occasional use it can certainly liven up even the most mundane of images.

△ **'Ripple' filter**
The 'ripple' filter produces an effect rather like that of viewing the scene through textured glass. Avoid strong backgrounds or it starts to be difficult to make out the subject.

△ **'Glowing edges' filter**
This clever filter finds edges within the image and then reverses their colours and tonality for a creative and eye-catching effect. It can also be used successfully on text within images.

Creating Artistic
Effects

Creating artistic effects is easy with a computer. Most software packages include a range of special filters that can completely transform the image in just a few minutes. So if you gave up your artistic aspirations when you were younger because you found it hard to draw or paint, here's the opportunity to try again – but without the need for months and years of painstaking practice. Exactly what effects are available depends upon the software you use, but most include popular effects such as watercolour, impressionist, pastel and coloured pencil. Initially you'll get great results just using the filters on their 'auto' settings, but with experience you can take control and start to experiment to your heart's content.

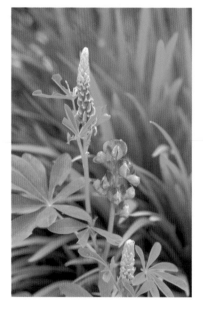

△ ▷ *'Pointillist' style*
Natural subjects of all kinds can benefit from an impressionistic 'pointillist' style, where the image is made up of many multi-coloured dots. This is one filter where you have to experiment to match the treatment to the subject.

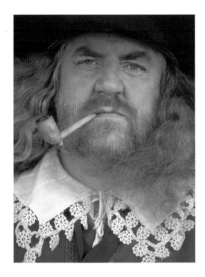

△ ▷ *'Watercolour' filter*
Watercolour pictures have lasting appeal, which is one of the reasons why the 'watercolour' filter is so popular – here giving an already strong image even greater appeal. This filter usually works well left to its own setting.

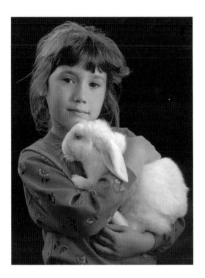

△ ▷ *'Palette knife'*
Using a palette knife successfully requires artistic ability, but creating pictures like the one on the right is just a matter of using the 'palette knife' filter. The larger the 'stroke size' you select, the more coarse the effect will be.

Vignettes

One way of making your images more interesting is to 'vignette' them. Letting the edges of the picture fade away to white (or black) can look more attractive than the blunt, squared-off look of conventional photographs. What's more, the effect can also help concentrate attention on the subject by cropping out extraneous, and often distracting, background information.

You don't have to anticipate what the effect will look like at the time of taking the picture. Some pictures are bound to leap out as candidates for vignettes once you have a range of images in your computer. Generally, it's better to go for a white vignette, which give pictures a light, airy feel. Darkening down the edges tends to produce a rather heavy mood.

△ ▷ **Interesting vignettes**
We've grown used to pictures being rectangles with straight edges – but once you're in the digital arena, they really don't have to be that way at all. In any image-editing program you can rub away the edges of the picture to create a more free-form effect. There are also specialist packages which make it all even easier.

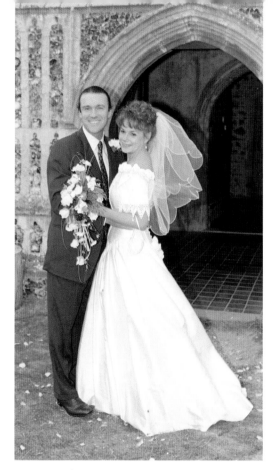

When to use vignettes

- to add an air of romance or nostalgia to your pictures

- to crop out unsightly backgrounds

- to create interesting edges

1 **Original picture** *The original picture is nice, but it is lacking something to give it that extra appeal.* ▲

2 **Cutting out a vignette** *Using the 'marquee' tool, an elliptical area of the image is selected, and the edge 'feathered' (see p.93) to give a graduated fall-off to the white.* ▲

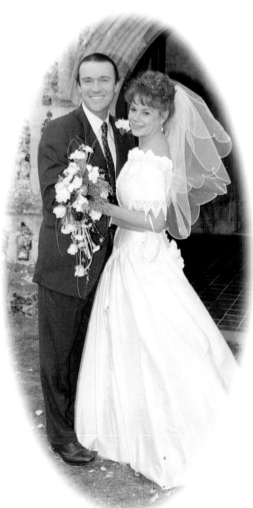

3 **As easy as that!** *With all the unnecessary detail cropped out and a most attractive vignette around the couple, the overall effect is much more pleasing.* ▲

Borders
and **Frames**

Digital imaging gives you options that aren't available in conventional photography. Instead of getting the print back and then going out and choosing a border or frame for it, you can incorporate them into the image itself. Many popular image-manipulation programs have built-in templates or 'guided activities' that make it easy to choose from dozens of different borders and frames – and you can usually control the size and position of the image within them. You can also buy software specifically designed for creating frames and edge effects, and if you do a lot of digital imaging this can be a worthwhile investment.

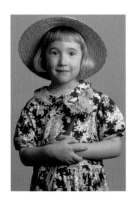

△ **Original picture**
The start of a digital imaging adventure.

▽ **Crayon effect border**
A specialist edge-effects software program gives you a multitude of options – such as this striking, coloured-pencil border effect.

▽ **Film-strip effect**
The whole feel of the image can be changed dramatically by adding pictorial elements such as this film-strip effect.

△ **Original picture – sisters**
Frame and border effects often work best with clear, simple images such as the one above. Do any necessary corrections and improvements to the picture before you add the effect.

▷ **Ornate and bold border**
Chosen to harmonize with the colours in the picture, this modern-looking border makes for a bold and imaginative combination.

▽ **Stained-glass border effect**
Not to everyone's taste perhaps, but this stained-glass border is one of hundreds you can choose from to enhance the picture.

▽ **Traditional wooden frame effect**
Looking for a more traditional effect? Then go for a simple 'wooden' border, which sets the image off a treat.

Combining Colour with Black and White

There are various ways of combining colour with black and white in a single image. One option is to make a copy of a colour original onto a second layer, convert it to monochrome, and then remove parts of either the colour or black-and-white layer, blending the two layers together to get the effect you're after.

Another alternative (shown here) is to start by stripping out all of the colour information and then colour in just part of the picture. This is quite a lot of fun, and surprisingly easy to do.

Working steadily and carefully, and varying the size of the 'brush' according to the size of the area you're colouring, you can soon create some appealing combined mono/colour images.

For an even more interesting effect you can try 'toning' the image before colouring it (see pp. 88–89), and starting with a sepia image can be particularly successful.

1 Original image
Start by choosing a picture with a clearly defined subject that will work well as a combined colour and black-and-white image.▼

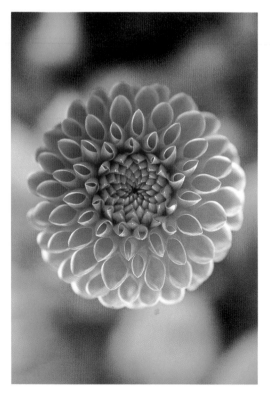

2 Open image in your manipulation software
If the picture comes from a digital camera you can import it directly into your manipulation program. If it's a print, negative or slide you will obviously need to scan it in first. ▲

3 **Convert the image to black and white**
In most image manipulation programs it's easy to turn a colour original to black and white. Simply convert it from colour to a greyscale mode, and it discards all the colour information. Make sure you keep a copy of the colour original. ▼

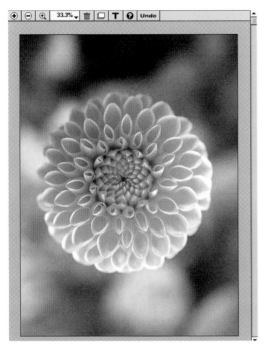

4 **Adding colour** Start by selecting a colour (or colours) and a tool to work with. Any of the 'painting' tools – pencil, airbrush, paintbrush – can be used. You will also need to specify the size of the brush. Then work slowly and carefully to paint the area you want to add colour to. ▲

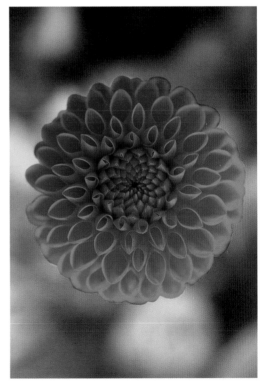

5 **Enlarging the image on the monitor**
You can be more accurate in your colouring if you enlarge the image to a high degree on the monitor – allowing you to do detailed work quickly and easily. ▲

6 **The finished image** It took less than half an hour from start to finish to produce this eye-catching image. As you become more experienced you can start to experiment with more than one colour. ▲

Colouring Black-and-White Pictures

Before colour photography was invented, skilled artists used to colour black-and-white pictures by hand. These days, with the universal availability of colour imaging, that's no longer necessary – but adding colour to a monochrome original is still worthwhile because the result is very different from shooting in colour in the first place.

1 Original image

Begin by choosing an image that doesn't have too much tiny detail. Then convert the picture to black and white by changing it from colour mode to greyscale mode. ▼

It's also a lot easier to do in the computer than it is by hand. Working in layers (see p. 72) means that any mistakes that you make can be corrected instantly, without affecting the original in any way. You can also make the colouring as broad or as detailed as you like.

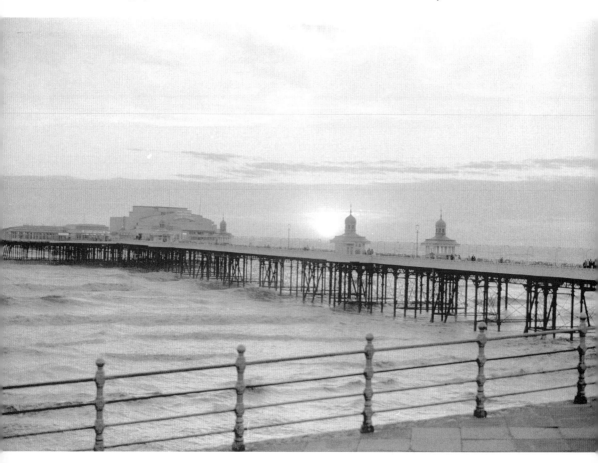

2 Colouring layers
Create a separate layer and apply bands of colour to different areas of the scene. Using layers this is quick, easy and controllable. ▲

3 Blending the layers
Careful adjustment of the colours and blending of the layers is required to give the best effect. ▲

4 The end result
An image such as this, with broad areas of colour and not much detail, can be completed in just an hour or two – and the eye-catching effect is well worth the effort. ▼

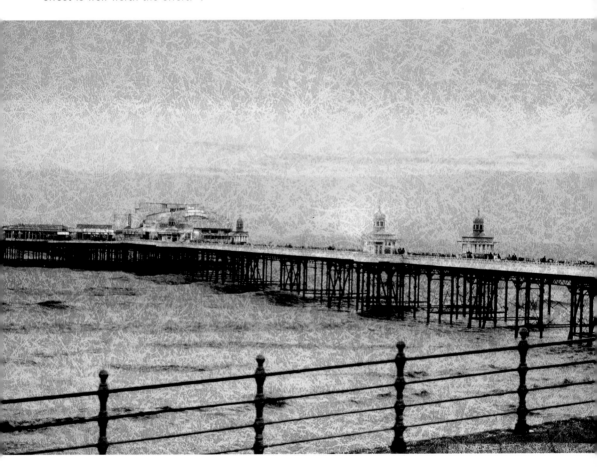

Adding Mood

Call it mood, call it atmosphere – call it what you will – but those images that stand out from the crowd tend to have some kind of special quality. Rarely, though, is it just to do with the subject – it's more to do with the way in which the subject has been treated.

This is where digital imaging comes into its own. You are not dependent upon everything being right when the picture was taken, or having made the best decisions at the time. Once the image is in the computer, you are free to determine what you need to do to make the best of it, without the pressures of changing light and weather. There are many ways of adding mood, but two of the most popular – and successful – are softening the image and adding grain, both easily achieved using digital techniques.

△ ▷ **Soften it**
Modern lenses can be too sharp and a little unforgiving with some subjects. While you can fit a soft-focus filter at the time of taking, the most controlled way of creating a diffused effect is in the computer, where you can try out different degrees of softness.

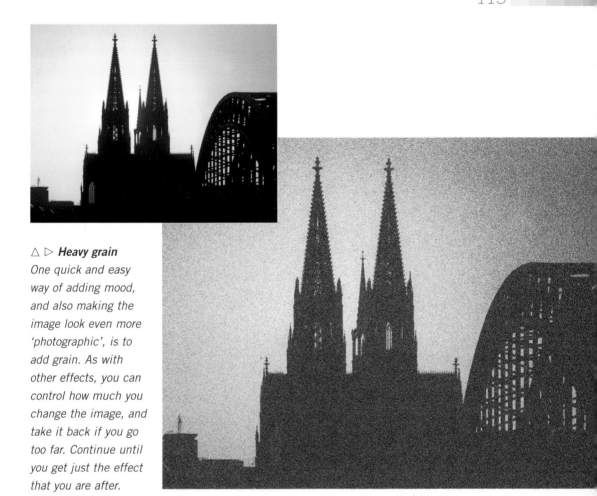

△ ▷ **Heavy grain**
One quick and easy way of adding mood, and also making the image look even more 'photographic', is to add grain. As with other effects, you can control how much you change the image, and take it back if you go too far. Continue until you get just the effect that you are after.

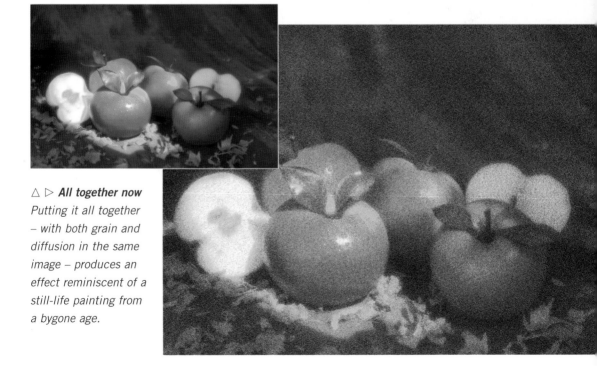

△ ▷ **All together now**
Putting it all together – with both grain and diffusion in the same image – produces an effect reminiscent of a still-life painting from a bygone age.

Adding a Sense of Movement

If you've ever tried your hand at sports and action photography, you'll know how hard it can be to come up with exciting results. Use a fast shutter speed to freeze the action, and all too often it looks as if what was a fast-moving subject is standing still in your photo. But all is not lost – adding a sense of movement is something that digital imaging does well, with most software programs featuring a controllable range of blur options. You can even make static subjects appear to be moving.

▷ **Action montage**
Although this dramatic shot looks realistic, in actual fact none of the elements was moving. The plane and the background were shot separately and then montaged (see p. 116). The plane was cut out from its background, and the blur on the landscape was created using the 'motion' filter. Final touches were then added to make the image appear more credible.

△ ▷ **Zoom effect**
*Using a 'zoom' filter and painting out the
distracting background of this shot gives
an image with a lot more power.*

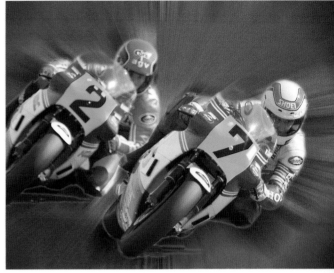

▽ ▷ **Adding radial blur**
*Bright and colourful it may be, but this
shot of a windsurfer is rather static.
Adding 'radial blur' centred around the
windsurfer's left knee makes the shot
come alive. Various strengths of blur were
tried, and this was the most successful.*

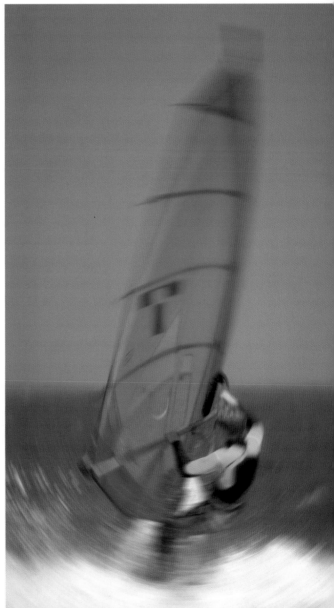

Changing
Backgrounds

▶▶▶ When taking pictures of people it's easy to get so engrossed by the subject that you don't notice what's going on behind them – and when you look at the finished picture you discover that the background is confused and distracting, or that the backdrop is dull and adds nothing to the composition. With digital imaging both problems are easy to resolve. All you have to do is cut out the subject and then combine it with the background of your choice. It's a good idea to build up your own library of images that can be used in this way. So keep your eyes peeled for subjects as you're out taking pictures.

▽ ▷ **From fact to fantasy**
While the expression in this picture is full of fun and excitement, the background hardly does it justice. But in digital imaging you can choose another background completely – whatever you want. A city skyline with the subject lit by flash? No problem.

1 Cutting out *The first stage is to cut the subject out from the background using the 'lasso' tool, and then tidy it up using the 'eraser' and 'rubber stamp' tools. You can then save the image and place it on other shots.* ▲

2 Slowly and carefully *To make the effect look convincing, you need to be painstaking in your cutting out. For maximum accuracy, enlarge the image as much as possible on the screen and work slowly and carefully.* ▲

3 A new backdrop *Then it's simply matter of choosing a new backdrop. You may have shots of your own or you can choose them from images provided by the software company or a royalty-free CD-ROM.* ▶

4 Perfectly natural *If you choose your subject and backdrop carefully, the result should look perfectly natural. What's most important is that are no obvious discrepancies in the lighting and that the size of the figure looks in perspective with the background.* ▶

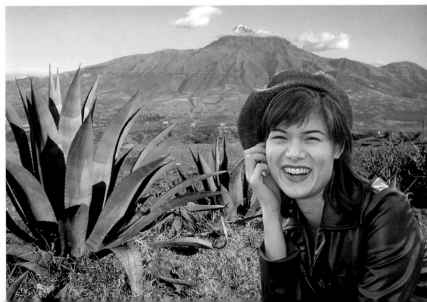

Blurring the Background

Concentrating attention on the main subject is one of the most important of photographic skills – and limiting the depth of field (see pp. 46–47) one of the best ways of doing so. However, not all cameras offer control over the aperture, and sometimes the background is so busy that it's just not possible to play it down sufficiently. This is where computer manipulation comes into its own. By isolating the subject from the background – either by cutting it out completely or simply by selecting the appropriate area – you can then tone down anything behind or around by using one of the many blurring options available.

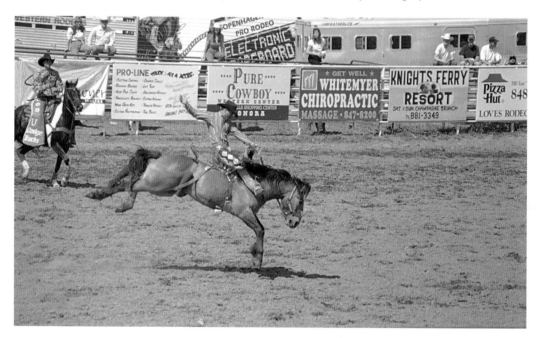

1 *Fussy background*
The subject of this shot – the rodeo rider – is really strong. But it gets lost in the busy and distracting background. Also, a fast shutter speed has frozen all movement, making the image far too static. ▲

2 *Cutting out*
The first stage was to roughly select the horse and rider using the 'lasso' tool – simply tracing around it until the 'marching ants' joined up – then copying the selection over onto another, separate layer. ▶

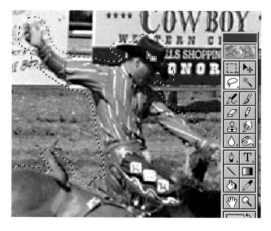

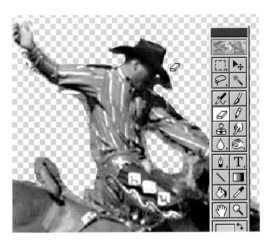

3 **Tidying up the selection**
Using the 'eraser' and 'rubber stamp' tools the selected area is progressively tidied up to give a clean 'cut-out'. ▲

4 **Blurring the hoof**
To enhance the impression of movement, the hoof of the horse has been selected and motion blur added. ▲

5 **Cloning and blurring the background**
The area from which the horse and rider were taken is cloned using the 'rubber stamp' tool. The upper two-thirds of the image was selected and 'gaussian blur' added to create blur. ◄

6 **Putting it all together**
The horse and rider were placed lower in the picture, to avoid the signs, and the shadow moved to make it seem higher off the ground. ▼

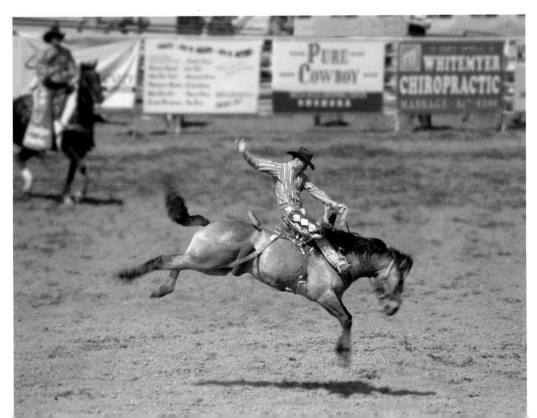

Creating Panoramas

▶▶▶ ▶▶▶▶ All too often the processed print or slide fails to do justice to what was a vast and impressive scene in real life. However, digital imaging allows you to recreate the most dramatic and inspiring of landscapes.

The secret of capturing that wonder lies in creating panoramic shots which come closer to the impression of having the subject all around you.

It's true that some modern cameras feature a panoramic option, but in practice these are limited by the lens – many are simply not sufficiently wide-angle to get as much as you would like into the picture.

Working digitally, there is no such limitation. All you have to do is shoot a series of pictures using a film-based or electronic camera and then 'stitch' them together to produce an image that is as wide as you like.

Having done that, you can also make any other change that would be beneficial, such as stripping in a whole new sky or boosting the colour.

1 Starting point
By swivelling from the hip the photographer captured five separate images, which can then be combined into a single panoramic image. ▼

2 Stripping in a stormy sky
The photographer also selected a picture with a stormy sky to add to the combined image. ▼

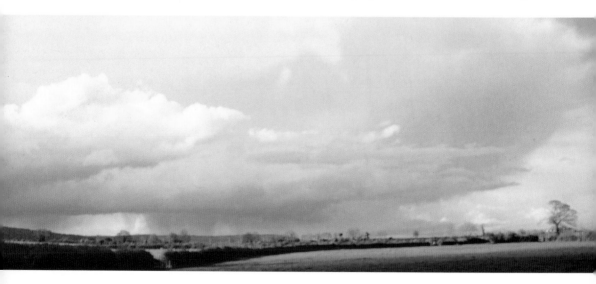

3 Panorama

Each of the five images is placed on a separate layer and then lined up so they join to create a continuous scene. ▶

4 Balancing

Then it's just a matter of blending the images so they match in terms of brightness, contrast etc. ▼

5 Finished image

Once all of the images have been put together, the colour of the resulting image can be boosted. The finishing touch in this sequence involves stripping in the sky from another image (see bottom left).▼

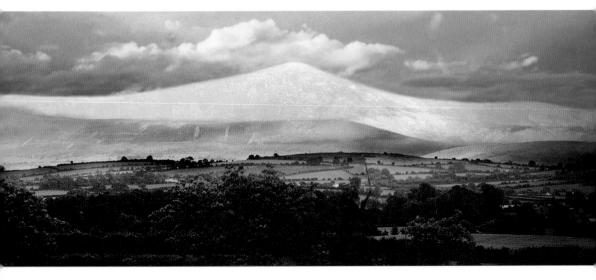

Combining Images

An easy way of improving your images is to replace the unsatisfactory parts with areas taken from other pictures. This is particularly useful with groups of people, where not everyone has their best expression in the same shot. The principle is simple: copy the replacement area at the same resolution as the image you're pasting into, cut it to shape, position it, and then blend it in to make it look real.

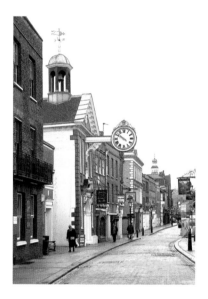

1 *Original picture*
The dull, flat lighting of an overcast day means lots of detail is recorded – but the sky is washed out and lacking in interest. However, that problem can easily be rectified. ▶

2 *Rubbing out the old sky*
Using the 'eraser' tool, it is an easy job to rub out the sky. Enlarging the image so that the individual pixels can be seen will allow accurate retouching. ▲

3 *Adding the new sky* *Once the old sky has been erased, it's a simple matter of adding a new sky from a different picture and blending the two images together to create a natural look.* ▶

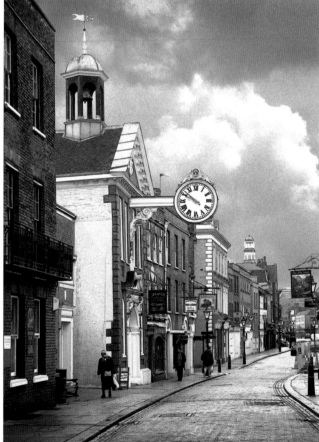

1 ***Boy smiling – woman looking down*** *Here the animated expression on the boy's face is wonderful, but the picture doesn't really work that well because the mother is looking down, rather than at the camera.*▲

2 ***Woman's expression fine – boy's not*** *In this shot it's the boy's expression which is less than satisfactory, while the mother's expression is warm and attractive. Neither shot works on its own – but they can be combined.* ▲

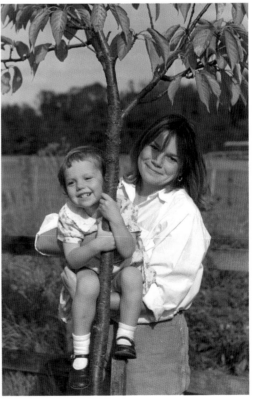

3 ***Copying the head over*** *Make a copy of the 'good' mother head, cut it out carefully to shape, and then paste it as a new layer onto the other image.* ▲

4 ***Blending it in*** *The fit between the head and the background won't be exact, so you will need to use the 'rubber stamp' tool to 'tidy up' around the heads for a clean result.* ▶

Pseudo-infrared

▶▶ ▶▶▶▶ ▶ ▶▶▶ ▶

False colours and vivid saturation are just two of the hallmarks of colour infrared photography – a dramatic image technique which involves using special films sensitive to the extreme red end of the visual spectrum, along with filters over the lens of the camera.

Results can be spectacular when you get it right, but are rather difficult to predict.

Similar, though not identical, effects can be created in the computer. This is done simply by manipulating the colour and saturation of different parts of the picture.

△▽ **Creating an autumnal effect**
This wood certainly had the potential for an interesting photograph, but the overcast weather and flat lighting resulted in an image that is drab and lacks impact. An autumnal scene might have been

much more striking. With digital photography you don't have to wait until the right season for such a picture. You can create the effect instantly from the original picture, using controls available in most popular image-manipulation packages.

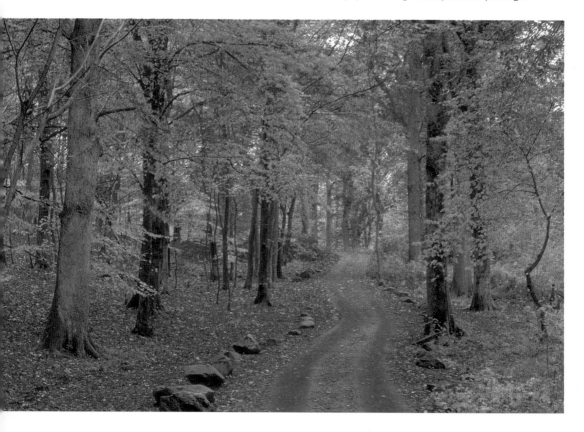

1 Adjusting hue and saturation
On many software packages changes can be made to the colour of the image by means of sliders – which allows precise control over the result, often with a preview window that shows you what is going on. The more you slide the control to the extreme of the range, the more dramatic the effect will be. Here you can see the settings that were needed to go from the green wood to the autumnal one. ▶

2 Pseudo-infrared
Using the autumnal picture as a starting point, and reducing the hue and increasing the saturation, it is possible to produce weird and vivid colour effects quickly and easily. The treatment doesn't suit all subjects, of course, and would quickly become tired if you used it a lot. Here it works well, creating a futuristic landscape similar to that which you would get if you shot on infrared film. ▶

3 Pseudo-infrared effects
With this kind of creative image-making there's no right or wrong – so it's really just a matter of experimenting until you get a result that looks right to you. Maybe you like this... ▼

4 Alternative effects
... or maybe you prefer this. It only takes a few seconds to change from one to the other. A whole gallery of effects can be produced in the course of just ten minutes. ▼

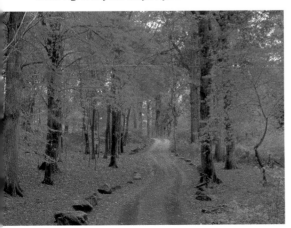

5

Uses of Digital
Photography

Repairing a
Damaged Print

Most of us have a treasured collection of old prints, many of which have seen better days – they may be scratched, scuffed, or gently fading away as the years pass. If you have a scanner, copying and restoring them is a viable and satisfying option. In some cases, not only can you bring old images back to their former glory, you can improve on them. And once you've restored a picture, you can print off as many copies as you like to give to relatives.

1 *Damaged original picture This old picture is scratched and marked, so you need to scan it in at the highest resolution possible. ▶*

2 *Rubber stamp tool Select the 'rubber stamp' tool' and a 'brush' size to match the blemish, then 'clone' the colour and texture from an area adjacent to the one you want to replace by holding down the option key and clicking the mouse. ▼*

3 **Filling an area**
After that, place the 'brush' of the 'rubber stamp' tool over the blemished area that you want to replace and click the mouse once again. Keep cloning and replacing as necessary to repair all the imperfections. ▲

4 **Restored picture**
Once all the blemishes have been done, consider if anything else needs doing. For instance, areas may need lightening, darkening or sharpening. By the end the photo may be better than it was when taken! ▶

Dust off your prints

Some of the leading image manipulation packages available include a 'dust and scratches' filter designed to remove imperfections quickly and easily, but in practice they're no substitute for careful and meticulous restoration.

Adding Text to Pictures

▶▶ ▶▶▶▶ Though it's undoubtedly true that a good photograph can be worth a thousand words in itself, sometimes adding a few words to an image can make all the difference. With a portrait you can add the name of the person or some suitable caption – or if you've created a composite of images, perhaps a heading that seems to sum it all up. Then, of course, there are birthday and other greeting messages. It's the same with landscape and travel shots. It really is easy to add simple text to an image – and not much more demanding to produce something just a little more special.

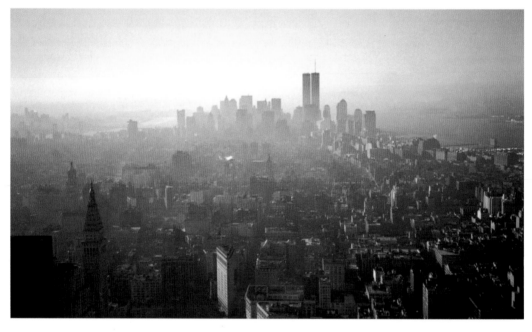

1 **Original picture** *Start by making a copy of your original picture* and carry out any essential image corrections or improvements. ▲

2 **Add text** *There's a text tool in most image-editing programs, and* once you have selected it you can simply start typing onto the image – with the text usually saved on a separate layer. ▶

3 **Using the image** *A more sophisticated way of working is to copy part of the image into the text. The exact procedure depends upon the program you are using, but it generally involves copying and pasting from the background image, using the text as a template. Because the text is on a separate layer, you can move it around the image so that you can find out where it works best.* ▶

4 **Adjusting the opacity** *You can vary the ways in which the layers blend or merge, and here that facility has been used to allow the cityscape to be seen through the text.* ◀

5 **Finished picture** *Combining the two images to create the finished picture produces an effect that is a dramatic improvement on the original.* ▼

Greetings Cards

Those with layout/design software, included as standard with most computers, will find it easy to make their own greetings cards, posters, calendars etc. This is much more satisfying than buying them from a shop, and has the added advantage that the content can be personalized to the sender and receiver.

Here, we are looking at ways of designing a simple Christmas card – but the principle is the same, whatever the occasion or subject matter. It's just a matter of producing a suitable background and adding text. Many image manipulation packages also feature 'guided activities' that allow you to produce more sophisticated cards with fancy graphics.

1 *Starting picture* *Choose a picture that suits the mood and the context of the card you want to send. This frosty scene is perfect for a Christmas card.* ▶

2 *Create the page* *Using design or layout software, create a page into which the picture will go. Our card will be 8¼ x 5¾ in (206 x 145 mm), and can be output on a standard inkjet printer and then folded over in a normal card design. Place a picture box in the middle of the layout, with a coloured border all around.* ▶

3 **Putting it together** *Once the picture has been dropped in and sized to fit, you can see how well it's coming together and think about adding some text. If you don't like the border colour, you can also think about changing it.* ▶

4 **First words** *Create a text box and add your message (see pp.130–31). Choose a type style that seems to suit, and adjust the size and position until you are happy with it.* ▶

5 **Multinational** *Since this card is intended to be multi-national, the message 'Merry Christmas' has been added in several languages – though you might only want to use one.* ▶

Websites

and E-Mail

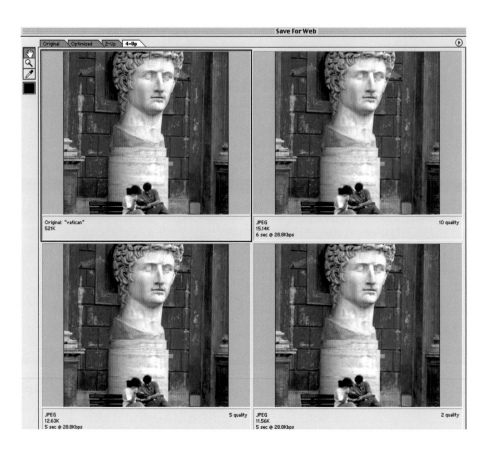

One of the great advantages that digital images have over conventional photographs is that there are many different ways you can share them. As well as making prints and passing them around for family, colleagues and friends to see, you can send digital images anywhere around the globe in seconds via e-mail.

Alternatively, you can put them up on your own web page for the world to peruse at its leisure. However, before you start moving images around in this way you need to give careful consideration to their resolution and size to avoid long transfer and download times.

△ **Reviewing image quality**
Some software packages allow you to compare the loss of quality and download times at different degrees of compression.

Images for the World Wide Web

While having a website is considered pretty much essential for companies these days, many individuals are also sharing their interests and experience with others by putting their own pages on the Internet. Images are essential if you are to capture and hold the interest of a passing surfer – but if the images take a long time to

load the person will have moved on and the opportunity is gone. There are three key ways of limiting the size of the file:

Saving the image
Start by saving the image at 72 dpi. This is the optimum resolution for computer monitors, and normally reduces the file size considerably.

Reducing the image size
Reduce the actual number of pixels in the image so that it is exactly the size you need it to be on the web page. Go to the 'image size' function and specify how many pixels in each direction or the actual dimensions you require. Somewhere around 768 x 1024 pixels is right for a 17 in (430 mm) screen.

Compressing the image
Save the image in a compressed format. JPEG (also JPG) is the most common and popular Internet format. You do lose a certain amount of quality as a result of the compression, but that would only be noticeable if the image were downloaded and then decompressed again. You can choose the compression ratio yourself. Lots of compression gives a very small file size that loads quickly, but image quality may suffer; little compression can result in too large a file size. As a rule of thumb, if you want it to fill the screen, go for medium compression so that the finished file size at 768 x 1024 pixels is around 100 Kb.

E-mail
Deciding what resolution and compression to use when sending images by e-mail will depend to a large degree upon what the person will do with them when they receive them. If they will simply view them on screen, the same guidelines apply as for preparing images for uploading to a website: 72 dpi, reduce to 768 x 1024 pixels,

△ **Original image**
This original image is of a high quality.

△ **JPEG image**
A lower-quality JPEG image for the web.

Steve Bavister
Home Page

△ **Simple website**
Images need to load quickly on websites, and JPEG is the ideal format.

and compress moderately to give a file no bigger than 100 Kb. But if the other person wants to print out the picture, or intends to use it in a newsletter, report or book, then different criteria apply. You may want to retain a higher resolution, perhaps 240–300 dpi, and go for a larger number of pixels, but still maintain a medium degree of compression. If you're not sure, do a series of tests with your own printer to get some idea about what size is needed, and take note how long it takes for different-sized image attachments to be e-mailed.

Digital
Photo Album

◁ **Photos at a glance**
*An ideal way to store your
pictures is in a digital
photo album on your
computer. This will help you
to enjoy and manage your
ever-increasing number
of photographs.*

As your enthusiasm for digital imaging grows, so will the number of pictures you create – and it won't be long before you're struggling to keep track of them. Different people will have different ways of tackling the problem, and you may find a way that works for you. But ultimately you may find it worthwile investing in special software that works like a digital photo album, cataloguing them in a way that allow you to find your images quickly and easily, and view them in the way that is most useful for you.

Organizing your images

While some software packages already include facilities for organizing your images, it can be worthwhile investing in specialist software that makes it possible to search for a particular shot in as many ways as possible. As long as you supply detailed information when you store the image, you may be able to locate it by means of any of the following: the subject matter; the date it was created or catalogued; the file name; the file size; the last time it was modified; and, for those with several drives, where it was saved. Most cataloguing software packages have a user-friendly interface that displays thumbnails of the images for easy recognition.

Setting up a digital slide show

In the old days, keen slide photographers would set up a projector, erect a screen, darken the room, and show their best images to family and friends. And one of the great things about digital imaging is that it makes it possible to do all that much more simply and easily.

If the images are stored on a digital camera, they can normally be shown directly on a standard television simply by connecting the two together using cables that were provided with the camera.

△ **Digital slide show**
An easy way to share your pictures with others is to give a digital slide show.

If the pictures are in the computer, it's worth checking whether your software programme includes a 'slide show' option, in which the images in a specified file are shown on the monitor one after the other at user-defined intervals, say every five seconds – and you and your companions can simply sit back and enjoy the show. If not, you may have business software such as Microsoft Powerpoint which offers this facility. Or, if all else fails, you can open and close each image successively yourself.

Organizing a digital portfolio

If you are a professional photographer, or have aspirations to be, you will probably want to set up a digital portfolio that you can show to prospective clients – rather than having to carry a heavy case full of prints and transparencies around with you. Ideally, the portfolio will be in a format that allows you either to show it to

someone on a laptop computer or on their machine, or to supply it to them on a CD so they can peruse it at their leisure. Once again, specialist software is available to make producing something of a professional standard relatively easy. Another option is to organise your portfolio as a website which clients can access whenever they want, wherever they are, and then you can copy the files to your hard drive or a CD for individual presentations.

Organize carefully

Think carefully about how you organize your images, so that the images flow easily and effortlessly from one to the other.

6

Next Steps

Limiting your
Palette

Because the real world exists in full colour, there's a tendency to try and reflect that in photography. But sometimes you can create a more interesting and powerful effect by limiting your palette – by using a more limited range of tones and colours in a picture.

The picture could consist of just one principal colour, perhaps enhanced or contrasted with one or two others. Or you could take two or three colours and work with them, perhaps with a monochromatic image as a starting point. Alternatively, you could soften down the saturation, so that you get a range of muted colours that work more harmoniously together.

Whatever your approach, the tools are available to you in digital imaging, so just experiment and use your imagination.

▽ **Bold colours**
Painting areas of a black-and-white image with bold blocks of colour results in strong impact. The secret lies in working in layers (see p.72) in a methodical and careful way.

Ice of Dreams and
Mysteries

◁ **Ice blue**
By working almost
exclusively with the
blue palette in this
composition, the
photographer has been
able to create a sense
of cold and mystery –
which is enhanced
by the subject and
the high-contrast
treatment.

▽ **Muted colours**
Dramatically reducing
the saturation and
softening the mood
with grain results in a
highly atmospheric
composition with
muted colours.

Playing with
Pattern

If you produce a striking image, why leave it there? Playing with pattern is a great way of making the most of your interesting work.

By cutting out part of the picture and then using it several times over – perhaps in different sizes or colours – you can build interesting imaginary worlds of pattern. As well as having a lively imagination, the secret of success in this kind of work lies in attention to detail – carefully cutting out the subject and blending the repeated versions together.

▽ **See-through patterns**

The first stage in making this highly imaginative image was to scan various shells and starfish on a standard flatbed scanner and then, in the computer, cut them out and colour them so they were against a transparent background. Then it was a relatively simple job to vary the sizes and make some of them partially opaque.

◁ **Twirling legs**
You don't have to stick too closely to reality – why not let your imagination run riot? Once the legs and shoes had been cut out and the colour enhanced, it was an easy matter to repeat them at difference sizes. The background image was created using a 'twirl' filter.

▷ **Imaginative patterning**
Try changing the item you want to repeat as radically as possible. Here, various effects have been used to create the multicoloured larger version of the butterfly. The two butterflies have then been combined to create an exciting but balanced composition.

▽ **Six of the best**
A simple idea superbly executed. The triangular composition of the girl has been cut out and then repeated six times to create a long, thin composition. Careful blending of the images has paid dividends, and the blue toning is the icing on the digital cake.

Creating
Reflections

The speed and ease with which it's possible to copy and combine images in the computer means that you should always be on the lookout for creative options. One simple but effective technique, with suitable pictures, is to produce a mirror image 'reflection'. Most software packages allow you to copy the image you're working on in seconds, often with a single click of the mouse. Then it's just a matter of lining the pictures up so they make an interesting composition, and tidying up the areas where they join. Using this approach, you can even create complete mosaics.

▽ **Original image**
For the best results, start with an image that's strong in its own right – with plenty of contrast and colour.

▽ **Double the fun**
The first stage in creating the impressive composition below was to make a copy of the image onto a separate layer and then 'flip' it – so it was a mirror of the original. The two images were then butted up to each other and the layers merged. As a final touch, the resulting image was stretched vertically to open up the perspective.

△▽ **Four images in one – with added ripple**
Many photographers would have been perfectly happy with the moody and atmospheric original above – but here it has been used as the basis for a much more ambitious composition. Having made a copy on a new layer, flipped and merged it with the original, this combined image was copied again and flipped again – but this time vertically – and merged so that the image was now repeated four times. To break up the symmetry and make it more believable, the ripple and sunrise effect at the left were also added.

Creating Abstract Shapes

One way of developing your digital imaging skills is to set yourself a project – and that's what one enterprising photographer did using perfume bottles as the starting point. Using an ordinary digital camera and simple set-ups, he captured hundreds of images of different shaped bottles – all of them illuminated by the light coming through a large window.

The best of the images were then selected and the backgrounds were cut out – which is when the fun began. Using the 'layers' facility and the 'blending modes' option on his image-manipulation program, he set about using his design creativity to come up with dozens of different abstract compositions – of which just a few are shown here.

△ **Colour kaleidoscope**
By repeating images of a bottle around a central pivot point, a kaleidoscope of colour was created. Each image was saved onto a separate layer and then blended together at the end.

◁ **Curved bottles**
Making copies of the image of this bulbous perfume bottle, and changing the colour, saturation and contrast, helps to emphasize the curves. Experimentation is the name of the game.

△ Clean white background

This image allows the curvature of the bottles to be seen clearly against a clean white backdrop – unlike the other pictures, all of which have something colourful going on. The illumination of the subject from behind can be seen clearly.

△ Multi-coloured bottles

If you like colour in your images, there's plenty to please here. Tipping the bottles together creates a triangular composition, while the circle behind holds it all together. Once again, it's the image blending that makes the shot.

◁ Figure work

Placing a figure study inside the bottle, using contrasting colours, takes the image into a whole new dimension.

▷ Overlap

What's interesting is how the three bottle shapes overlap, creating new and often surprising shapes in the process.

Montaging Images

Once you've mastered the basics of digital imaging, it's a natural step to start combining several pictures into new and original compositions. And though initially you might find such montages challenging, you'll soon progress from bringing two or three subjects together to more ambitious projects. The key to success here, though, lies in having an interesting idea in the first place, rather than just throwing together a collection of disparate images.

▽ **The eyes have it**
Working against a black background is a good way to start in montaging. Having cut out the image, the photographer copied it and 'flipped' it so that it faced the opposite way. Then it was simply a matter of overlapping the faces and carefully blending them together. The hand, which is not doubled, was added afterwards.

△ **Self-portrait**
At first sight this self-portrait montage looks incredibly complicated – but when you study it carefully, you can see that it is actually made up of a dozen or so images that have been combined to make an original whole.

▷ **Relating elements together**
Montaging can allow you to tell a story by combining various subjects that would never be seen together in real life. Here, a light bulb is seen with the power station that illuminates it.

Creating Painterly
Effects

One of the reasons so many people get interested in photography is because they want to be creative visually but don't have the skill to draw or paint – or the time to develop it.

That's why digital imaging is so perfect. Starting with a normal photograph, it's relatively easy to create a composition that is virtually indistinguishable from a painting. Simply selecting one of the many artistic filters in your image-manipulation package is a good place to start – though you may quickly find you want more control and start combining some of the options available.

What's more, you can keep making subtle changes and adjustments until you're fully happy with what you've come up with – and, of course, you don't have all the cost of the materials.

▽ **Canvas texture**
Most popular image-manipulation software features a filter that will give images a 'canvas texture' effect like an oil painting. Combining this with other artistic filters can work beautifully.

Be imaginative!

Don't just use artistic filters on their automatic settings – be more imaginative and see what happens when you dial in different strengths.

- try also adding grain or blur

- have a go at changing the hue and saturation of the image as well

△ *Experimenting*
Many digital imaging enthusiasts work intuitively – manipulating their images until they come up with something that works, and reversing any effects that don't improve the image. This picture was worked on extensively using various filters as well as saturation, colour, brightness, hue and contrast controls.

▷ *Poppies*
Not happy with the original backdrop, the photographer replaced it with a scan from a metal sheet. Using a 'fresco' filter gave the painterly quality, and the overall contrast and colour were then boosted using the saturation controls.

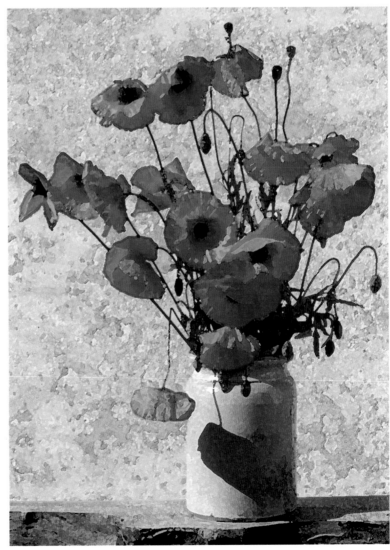

Using Colour

Powerfully

Many pictures lack interest because their colours are flat and bland – and correcting them can go a long way to making the photograph more appealing (see pp. 82–83).

But sometimes that in itself is not enough, and the colours need turbo-charging if the image is to realise its full potential. Don't just tinker with the saturation and hue, put your foot to the pedal and test the limits of what is and isn't possible.

The key thing here is to set aside any idea of what's right or wrong, or of keeping faith with what the subject was actually like. What you need to be asking yourself is: 'Does this make the image more powerful?' and 'Does it add to the impact?'

If so, it's worth doing.

▽ *Dramatic colour*
By using the layers controls you can cut out various picture elements from the background, completely change the colour, and montage them together.

△ **Hyper-colour**
You don't have to go completely over the top in order to make interesting use of colour. Using the 'channels' control you can strengthen one or two colours – such as the yellow here.

▷ **Vivid reflection**
Experimenting with the saturation and hue controls allows you to create colours which are far more vivid than you would ever see in real life. The results, as here, can be dramatic.

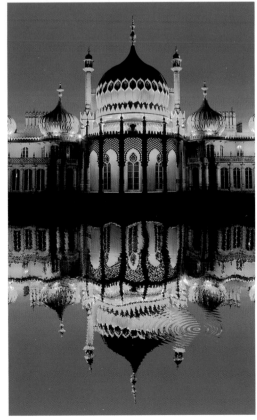

Secrets of success

• when combining several images make sure you place each one on a separate layer

• use the 'channels' control to adjust just one colour

Emphasizing
the Subject

Most pictures that work well have what is known as a 'focal point' – a clear subject which the viewer's eye goes straight to.

This can be achieved compositionally, by the positioning and framing of the subject in the scene, or optically, by setting an aperture which will throw the background completely out of focus.

Digital imaging, though, opens up a whole host of possibilities for emphasizing the subject. Mask it off or cut it out from the background completely, and you can make changes to both independently – allowing you to control everything from colour to sharpness. You can also apply filters to the background so that it projects the subject forward even more.

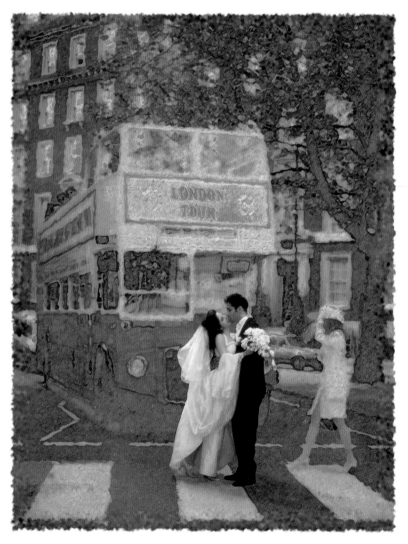

◁ **Real and unreal**
One very simple way of making your main subject stand out is to leave it untouched while radically changing the background. By desaturating the bus and the buildings, and applying artistic filters, it has been possible to make the newly married couple stand out against the altered background. Such compositions are also easily created by montaging images taken at different times.

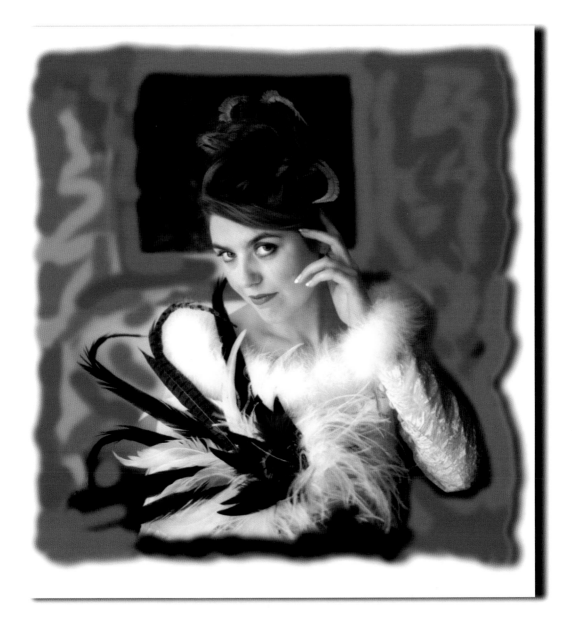

△ **Change a backdrop**
Cutting a subject out
carefully and placing
it and the background
on separate layers
allows you to make
independent changes
to the background, to
help the subject stand
out – such as blurring
or softening it, toning
down the colour, or
even painting over it.

Separating out the subject

Working in layers offers optimum control over an image, but
it's also possible to change the subject or background of an
image that is not composed of layers. Using a selection tool
(such as 'lasso' or 'marquee'), select the area you want to
work on – any changes you make will affect only that part
of the image. You can also 'invert' the selection so that
only the outside area – i.e. the background – is changed.

Glossary

attachment File, such as a digital image, sent with an e-mail

byte Small unit of computer memory (see kilobyte, megabyte and gigabyte)

CCD Stands for Charge-Coupled Device – the sensor in a digital camera that creates the digital image

CD writer Hardware unit that lets you write your own CDs – ideal for storing large number of images

CMYK Cyan, magenta, yellow and black (K) – combinations of which produce colour images on the printed page

CompactFlash One of a number of removable and reusable 'digital film' cards

compression Process that reduces the size of a digital image so that it requires less storage space, transmits more quickly by e-mail or downloads faster from the Internet (see JPG)

contrast Difference between the lightest and darkest parts of the image

CPU Central Processing Unit, another word for microprocessor

crop To cut away parts of the image that are not required

digitize To create a digital image – normally by means of a scanner or digital camera

download Receiving a file/image from a remote computer, often via the Internet, and generally using a modem (opposite of upload)

DPI Dots Per Inch, an indication of the resolution of a computer monitor, scanner or printer. The higher the resolution, the better the quality

drum Expensive scanner used by reproduction houses and bureaux

file format The way in which the image is stored (See TIFF, JPEG and GIF)

filter Software option for image enhancement

film scanner Scanner designed to digitize transparencies and negatives

FlashPath Adaptor which allows SmartMedia cards to be fitted into a standard floppy drive

flatbed scanner Scanner designed to digitize flat artwork such as prints and drawings

floppy Small, thin disk with 1.44 Mb of storage

focal length The optical length of a lens (see wide-angle and telephoto)

frame grabber Device that allows you to 'grab' an image from a video, camcorder, laserdisk etc

GIF Graphical Interchange Format, used to display images on the net. JPG is better for photographs, as a GIF is limited to 256 colours

gigabyte 1024 megabytes, or 1,048,576 bytes, often written as Gb

hard disk/hard drive Computer hardware that is used for storing images and other files. Some hard disks are built-in, some separate, others removable

image-editing software Computer program which can be used to acquire, manipulate and store digital images

inkjet printer Popular colour printer capable of producing photo-quality prints

interpolation Image-enhancement technique that increases apparent image size by adding pixels (but often with some loss of quality)

ISO International Standards Organisation – sensitivity rating system for film

Jaz Removable disk/drive storage system. Disks with two storage capacities are available – 1 Gb and 2 Gb

JPEG Joint Photographic Expert Group – the most popular, and useful, type of image-compression format

kilobyte 1024 bytes, often written as Kb

LCD Liquid Crystal Display – monitor that displays images on the back of digital cameras so that you can check the picture

magic wand Image-editing tool that automatically selects areas of similar-coloured pixels

marquee Tool for selecting part of the image

megabyte 1024 kilobytes, often written as Mb

megapixel One million pixels

microprocessor The 'brain' of the computer, measured in megahertz (Mhz)

optical viewfinder Direct viewing system found on some digital cameras

peripheral Any hardware item that can be added to a computer

Picture CD Mass-market digital format with all the images from a processed film stored on a CD and returned with the prints

Photo CD Scanning service offered by some laboratories, with up to five resolutions of each of 100 different images stored on a single CD

pixel Short for Picture Element, a tiny square of digital data containing details about resolution, colour and tonal range

pixellation Unwanted (usually) effect in which the pixels become so large they are visible to the naked eye

printer Computer peripheral for making hard-copy prints

RAM Random Access Memory

removable drive/cartridge/disk Useful storage addition to your hard drive which allows you unlimited storage

resolution Key indicator of the quality of an image, defined by multiplying the number of pixels down by the number of pixels across

RGB Red, green and blue, the three colours used to display images on a computer monitor

scanner Item of hardware used to digitize images, with types available for use with prints, slides and negatives

serial connection Simple cable connection, used for downloading images

SCSI Small Computer Systems Interface – an older industry standard for connecting computers with peripherals. Increasingly superseded by USB

SmartMedia One of a number of removable and reusable 'digital film' cards

telephoto Lens focal length which allows distant subjects to fill the frame

thumbnail Low-resolution image, found on digital software and the Internet, which finds the high-resolution files

TIFF Tagged Image File Format, a popular and high-quality file format

TWAIN Cross-platform interface for acquiring images from scanners

upload Sending files to a remote computer, often to go on a website, and generally using a modem

USB Universal Serial Bus, a computer connectivity system that allows many peripherals to be connected to a computer and swapped without the need to 'power down'

USM Unsharp Masking, process which improves the apparent sharpness of an image

wide-angle Lens focal length which takes in a wider view of the scene

Zip Removable disk/drive storage system. Disks with two storage capacities are available – 100 Mb and 250 Mb

zoom lens on which the focal length can be varied

Index

Acknowledgements

The author would like to thank all those who helped in any way to produce this book. In particular, Sarah Hoggett and Clare Churly from Collins & Brown for their their unwavering professionalism and patience, and Peter Bargh of DPFX magazine for providing contacts and the loan of equipment images.

All images and manipulations are by Steve Bavister, except for the following:

Page 2, Vincent Oliver; page 6, Tim Gartside; page 7, Barry Bevins; pages 16–17, John Henshall; page 59, Lee Frost; page 81, Barry Beckham; pages 82–83, John Henshall; page 84, Vincent Oliver; page 89 (top right and centre), Barry Beckham; page 90, Tim Gartside; page 91 (centre and bottom), Barry Beckham; page 93, Vincent Oliver; page 105, Vincent Oliver; page 111, Tim Gartside; page113 (bottom left and bottom right), Tim Gartside; page 114, Tim Gartside; page 115 (top right and top left), Steve Belasco; pages 118–19, Steve Brabner; pages 120–21, James Burke; page122, Barry Beckham; page123, Vincent Oliver; pages 124–25, Tim Gartside; pages128–29, Vincent Oliver; pages130–31, Steve Brabner; page 140, Daniel Valla; page 141 (top), Ian Coates, page 141 (bottom), Keith Adams; page 142, Yvonne Webb; page 143 (top and centre), Keith Adams; page 143 (bottom), Mark Cleghorn; page 144, James Burke; page 145, Steve Brabner; pages 146–47, Barry Colquhoun; page 148, Daniel Valla; page 149 (top), Daniel Valla, page 149 (bottom), Barry Bevins; page 150, Keith Adams; page 151 (top), Daniel Valla; page 151 (bottom), Ian Frost; page152, Keith Adams; page153 (top and bottom), Tim Gartside; page 154–55, Chris Hands.